CHICAGO PUBLIC LIBRARY
CONRAD SULZER REGIONAL LIBRARY
4455 LINCOLN AVE.
CHICAGO, ILLINOIS 60625

The John and Mary Jane Hoellen
Chicago History Collection
*Chicago Public Library*

CHICAGO PUBLIC LIBRARY
CONRAD SULZER REGIONAL LIBRARY
4455 LINCOLN AVE.
CHICAGO, ILLINOIS 60625

**SOUL IN THE STONE: CEMETERY ART FROM AMERICA'S HEARTLAND**

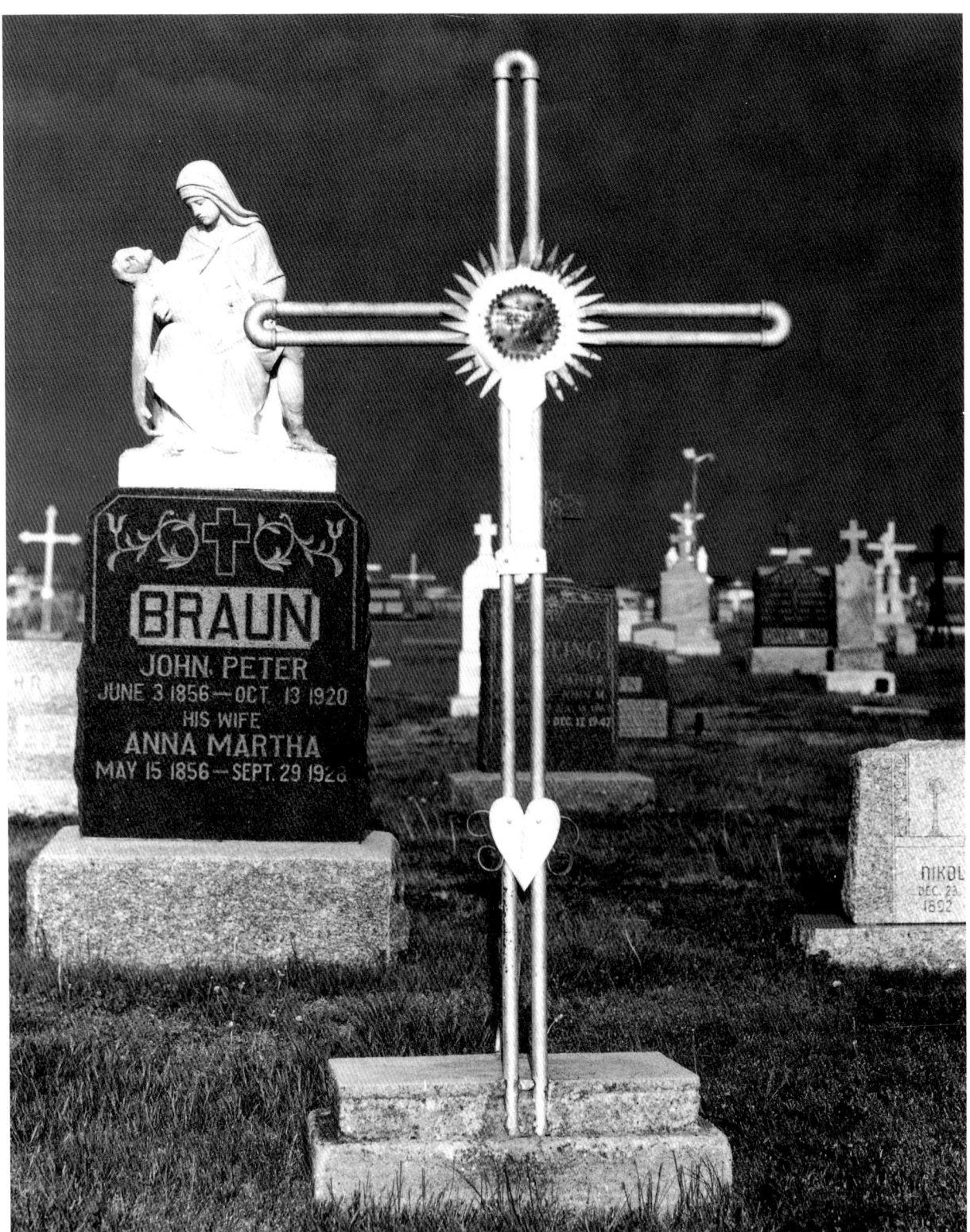

# SOUL IN THE STONE: CEMETERY ART FROM AMERICA'S HEARTLAND

John Gary Brown

UNIVERSITY PRESS
OF KANSAS

© 1994 by the University Press of Kansas
All rights reserved

Published by the University Press of Kansas
(Lawrence, Kansas 66049), which was organized
by the Kansas Board of Regents and is
operated and funded by Emporia State University,
Fort Hays State University, Kansas State University, Pittsburg State
University, the University of Kansas,
and Wichita State University

Library of Congress Cataloging-in-Publication Data

Brown, John Gary.
Soul in the Stone : cemetery art from American's heartland /
John Gary Brown.
p. cm.
Includes bibliographical references.
ISBN 0-7006-0634-3 (cloth : alk. paper)
1. Funeral rites and ceremonies—Middle West. 2. Cemeteries—
Middle West. 3. Sepulchral monuments—Middle West. 4. Folk art—
Middle West. 5. Middle West—Social life and customs. I. Title.
GT3205.7.B76 1994
393'.1'0977—dc20
94-18952

British Library Cataloguing in Publication Data is available.

Printed in the United States of America

10 9 8 7 6 5 4 3 2

The paper used in this publication meets the
minimum requirements of the American
National Standard for Permanence of Paper
for Printed Library Materials z39.48-1984.

**For Christy**

# CONTENTS

Acknowledgments
*viii*

The Cemetery and the Living
*1*

Religious Iconography
*50*

A Life Well Lived
*64*

Secular Images:
Familiar and Obscure
*95*

Children
*152*

Umbrella Organizations
*190*

Ethnic Influences
*207*

Ashes to Ashes
*240*

Bibliography
*245*

# ACKNOWLEDGMENTS

I would like to thank the following people for their help and guidance throughout the process of putting this book together: Bryan Anderson, Ed Boles and Michelle Minnis, Susan Brabant-Baxter, Barbara Brackman, Christine L. Brandt, Elizabeth R. Brandt, Sylvia F. Brown, Trudy Collins, Pam Davis, John Hachmeister, John and "Chick" Hood, Suzanne Houske, Ed and Mary Johnson, Carol and Charles Jones, Sheldon and Marcia Kushner, Benjamin Kushner, Cathy Kushner and David Lindholm, Gregg Markowski, Christine Mercer, Richard E. Meyer, Cynthia Miller, Larry Schwarm, David C. Sloane, Larry and Marion Thilking, K. T. Walsh, Cathy Dwigans and Ray Wilber, Nancy and Glen Woodard.

# SOUL IN THE STONE: CEME- TERY ART FROM AMERICA'S HEARTLAND

# The Cemetery and the Living

**W**e are all brothers and sisters in mortality, and our common preoccupation with death has produced countless cultural and religious practices that help us deal with the ultimate mystery. Ritual burial of the dead and the building of monuments to mark this passage are defining phenomena for most civilizations. The creation of literature and art objects, the raising of children, the formation of religious beliefs, the accumulation of family fortunes, and the buying of life insurance are ends pursued partly in response to our uneasiness about our brief linear role in nature's endless cycles. Although it may be true that one must encounter death alone, we fashion layers of ceremony, conclave, and accoutrement that we can experience collectively to create a kind of metaphysical moral support. These events and objects take many forms, but one of the most interesting is surely the cemetery, an institution that is nearly universal. Practically speaking, it is a place of entombment, but it is also, symbolically, built more for the living than for the dead.

Death has been marked and commemorated since the beginnings of human culture, reflecting an unwillingness to pass unnoticed into an ambiguous rebirth, a shadowy afterlife, or oblivion. Monuments are erected as a sign of love and respect for the departed, but they are also produced in order to reassure the survivors that each life will be remembered. More important, the cemetery enables us to proclaim our beliefs, give voice to our anguish or hope, and exercise our artistic inclinations. The cemetery ultimately becomes a repository of human values and expression, a place where orthodox religious beliefs and individual insights are put on display and can be evaluated and perhaps assimilated by future generations. Where artistic expression was once appreciated and encouraged, the cemetery is now an open air museum, a fascinating collection of surprisingly varied manifestations of the human spirit, mirroring its almost unlimited creativity.

Illustration of the partnership between human expression and the institution known as the cemetery is the overriding purpose of this book. The sources have been limited to a few states more or less in the center of the country. The prairie states of Kansas, Nebraska, Oklahoma, Missouri, and Iowa make up the narrow and traditional definition of "the Heartland," that geographical and philosophical repository of Americanism in its most innocent form. Adding Illinois, Indiana, and Wisconsin enables us to include more urban concentrations, while retaining the small-town values and virtues that we associate with the Heartland. The inclusion of "western" states Colorado and New Mexico acknowledges their true locations—partly in the prairie—and expands the narrow definition of the American heartland to include the mining camps of the eastern Rockies, worked mostly by uprooted prairie farmers, and Hispanic enclaves, settled by a north-

ward movement that continues today. The demographics of the United States are changing, and the redefinition implied by this altered map reflects that change.

The collective mark that we leave on our cemeteries goes a long way toward explaining who we are. By their nature, the statements made by funerary monuments are final, public, and not usually retractable. Since, as in most human endeavors, mediocrity and convention hold sway in terms of sheer numbers, we will concentrate our efforts on monuments that demonstrate artistic excellence or interesting concepts. The path of least resistance toward the prosaic hardly needs demonstrating, and societies are often defined more by their aspirations and extraordinary achievements than by the common denominators.

This book does not to attempt to catalog or document every meaningful fact or implication to be found in America's Heartland cemeteries. I wish instead to introduce the reader to a fairly comprehensive sampling of monuments, found and photographed in the course of travel and exploration with the help of a few friends and family members. Artistic expression and the role of the cemetery in the history of art are especially emphasized in the choice of material. I hope that this book will encourage others to explore, enjoy, and perhaps document outstanding Heartland cemeteries. The future of the American cemetery is in doubt, and this generation may be the last to have the opportunity to visit and document these regional and national treasures before they are lost to time and decay.

## The Classic Cemetery

The large suburban or "garden" cemetery that we are familiar with in most areas of the United States has its roots in nineteenth-century Europe. Before then, most European graveyards were clustered densely around the churches of an overwhelmingly Christian continent. Many of the elite were buried beneath the stone floors of cloisters or in the church floors and walls. With the exception of these privileged few, burial was crowded and free of frills. It was a time of unquestioning faith and unforgiving condemnation of those who strayed. For instance, separate cemeteries were constructed for those who took their own lives. Suicide was considered an affront to God, a slap in the creator's face and therefore a sin of the highest order. These cemeteries were surrounded by brick or stone walls that had no gates or windows, so that the dead had to be passed over the top of the wall by men on ladders, and visitation by friends or family was almost as unlikely as the forgiveness of God.

Even among the "respectable" dead, gravestones in eighteenth-century Europe and New England featured gruesome motifs like grinning, winged skulls, grim reapers, reclining skeletons, or Last Judgment depictions that emphasized horror and decay more than redemption. The absolute authority of the clergy depended on keeping the flock aware of the horrors awaiting the sinful. In France, even sculpted effigies of royalty were represented as partially decomposed bodies, lying atop decorative sarcophagi in the cold light of rose windows. In a typical Bavarian cloister, the grim reaper is depicted as a decaying corpse holding a scythe and striding through a collection of hats strewn on the ground.

The hats of soldiers, statesmen, dandies, and clergymen—all lie discarded in chilling, democratic anonymity. Although the cemetery reflects prevailing hierarchies as faithfully as any other institution, the implication was that these differences disappear at the entrance to heaven or hell. Images like these urged the visitor or mourner toward a hard and virtuous life, holding forth the promise of reward in the next world. Life was depicted as a dress rehearsal for the afterlife, and the churchyards obligingly continued to fill with those ready for the real drama. In Greece and other Mediterranean areas, bones were disinterred after a few years and consigned to the charnel house and eventually an unmarked grave. This practice could have alleviated some of the crowding in cemeteries across Europe, but it was unusual, confined mostly to Greece and areas where the Capuchin order of Catholic monks was influential. The Capuchins went so far as to construct decorative environments from the bones of their deceased brothers. In most Judeo-Christian societies, however, burial in consecrated ground was considered permanent—to be disturbed only on Judgment Day.

As European churchyards bulged, dirt and retaining walls added more vertical space, but by the turn of the nineteenth century the system was in crisis. Walls were disintegrating and collapsing, creating ugly and unhealthy conditions in the capitals of Europe. In some cases, such as the Cemetery of the Innocents in Paris, human remains were spilling out onto the streets as caretakers struggled to prop up and stabilize a no-longer-viable location for disposing of the dead. The crisis in health and aesthetics led ultimately to a political crisis, and resources were mobilized to rebuild the system from scratch. In Paris, millions of skeletons were moved from churchyards and stacked in underground quarries in decorative configurations. This bizarre passageway, known as the "catacombs," is now a tourist attraction. Like the Capuchins, the ancient dead of Paris are now, in effect, their own grave markers. With the past again buried, Paris turned its attentions to the prevention of subsequent disasters by inventing a new kind of cemetery that reflected the changing nature of European life.

The first of the so-called garden cemeteries was Père-Lachaise in Paris, which opened in 1804. The site of this new necropolis covered hundreds of acres, setting the standard that would be copied in London, Genoa, and Vienna. The new cemeteries were landscaped and rustic, in contrast to the weedy, jumbled burial grounds of the seventeenth and eighteenth centuries. There was room for pathways and even avenues—first for carriages and later for cars. By the time Père-Lachaise opened, society was tired of the grim preoccupation with symbolic decay and a lifetime of duty and sacrifice. People had dealt with too much real decay in the struggle to save the churchyards. In addition, the French Revolution had already fostered a more secular atmosphere in the cosmopolitan cities, and that new "worldly" consciousness eventually led to exuberant Victorian display. As the nineteenth century blossomed, men and women embraced life in the present, taking advantage of the higher standard of living to create pleasures and comforts for themselves that were unimaginable before. Medical advances, industrialization, and political reform produced an atmosphere of high expectations and a refusal to put off all indulgences until the next life. The church, while still influential, lost its iron grip on every aspect of daily life.

The new garden cemeteries reflected the emancipation and creativity of the age. Art

and nature were combined to produce a restful but stimulating environment. Visitors were no longer brutalized by harsh imagery but stroked instead by pleasing ensembles of sculpture, flower gardens, shaded paths that led to chapels or arbors of meditation, and mausoleums that combined architectural elements in a lush, almost playful way. The metamorphosis of the old graveyard into a culturally beneficial park led to the reintroduction of the word "cemetery," a place of repose. In place of traditional carved gravestones, sculptors produced lavish monuments that gratified the whims of rich merchant families. The eternal life of the deceased was emphasized and the torment of damnation was almost ignored. Individual responsibility for the salvation of one's soul, which to some degree supplanted the dominance of the mother church, led to highly individual expressions of faith and grief. There was also a new preoccupation with the mourners and family left behind by the deceased, and these grieving persons were often depicted in stricken poses, dropping flowers onto the grave. Sculpted portraits of widows and children, done in marble, are not unusual, and at times these portraits are succeeded by surrogate mourners, in the form of beautiful female angels or cherubs. Melodrama replaced the grim, businesslike acceptance of mortality of the previous centuries. Also, in a society formed by expanding possibilities, the building of spectacular tombs sometimes served as another form of social advancement. The monuments of an increasingly prosperous merchant and professional class used artifice and images that had been the exclusive preserve of royalty.

Social manipulation, present in all institutions, was inherent in the reinvented cemetery, just as in the old, but it was manipulation with a human face. Theological truth was still stressed, in conjunction with secular themes, and the public morality was still celebrated and strengthened. Regular visits to the cemetery by a typical family helped to build a sense of historical belonging; and special categories of burial, such as military areas, kept patriotic feelings strong. It was hoped that the physical and conceptual ensemble would confirm the learning of the wise and give the young an opportunity for uncharacteristic pensiveness. The living were still shown the end of all vanity, but the lesson was gentler and more constructive than the blunt instruction of the old churchyards. The most important difference between the two types of cemeteries was an attempt in the new model to assuage the suffering of the bereaved. Their pain was elevated and shared, the traditional salt withheld from the wounds.

Many elements of culture—art, architecture, city planning, gardening, history—were considered by planners when designing the new burial grounds. Poetry and epitaphs often provided the semiliterate with a chance to further their understanding of the written language. Visitors who did not ordinarily see works of art could marvel at the skill of the sculptors. Regular interaction of the public with the cemetery improved society's understanding and acceptance of the natural process of death and reinforced family feelings.

As immigrants were arriving in the United States in large numbers and spreading west onto the frontier, the new model of the cemetery was spreading as well. Although the most adventuresome pioneers left only minimally marked graves along the edge of the Oregon Trail and other migratory paths, groups who settled in the cities began organizing cemeteries based on those they had known in the old country. Although there was nothing to match the scale of Père-Lachaise in Paris or Genoa's Cimitero di Staglieno, the

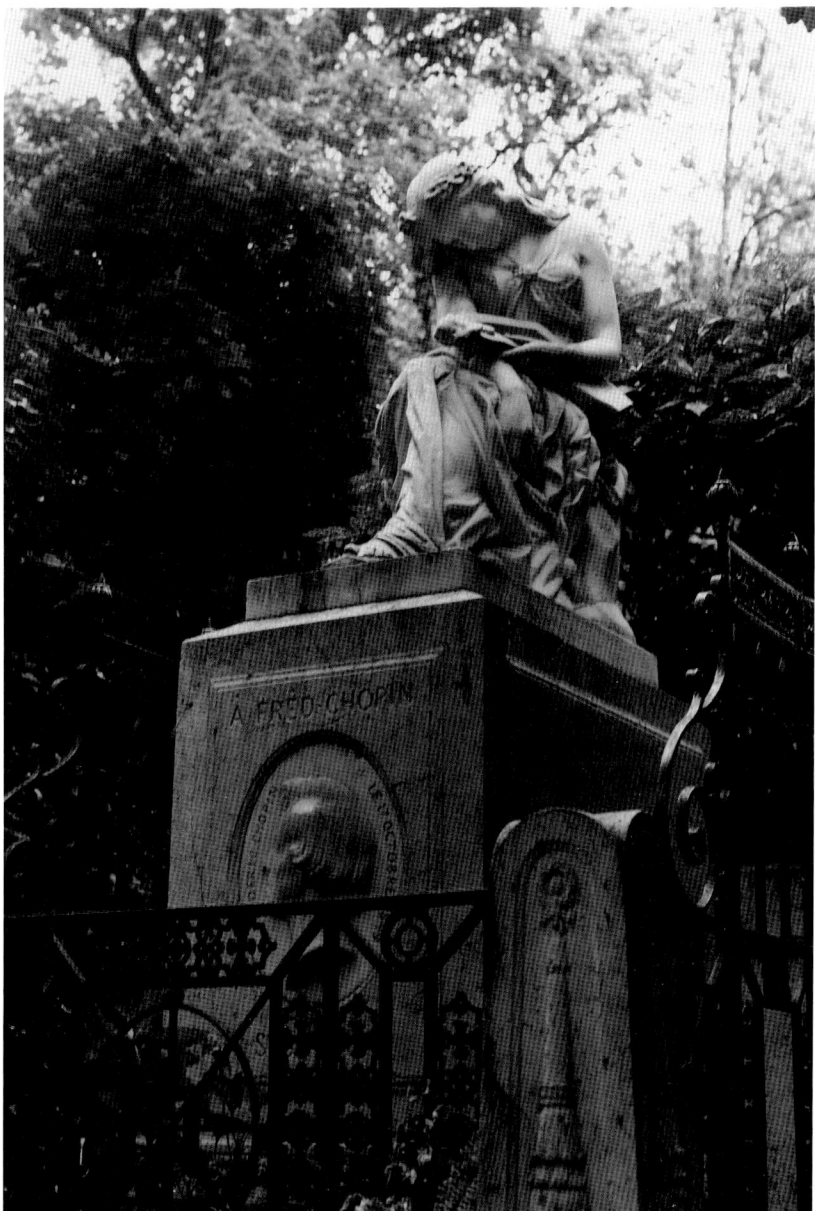

Chopin's grave, Père-Lachaise Cemetery, Paris

basic concept was kept intact. Skilled artisans came to the United States with the other immigrants, and for mourners of means the highest-quality Carrara marble monuments could be easily ordered from Italy. Mausoleums were erected for wealthy families and, as in Europe, architectural styles were mixed with artistic abandon.

The first major cemetery completely unrelated to any church or parish to be built in the United States was Mount Auburn in Cambridge, Massachusetts, in 1831, but Heartland imitations soon followed. Cemeteries like Bellefontaine and Calvary in St. Louis were built around the middle of the nineteenth century with the European model in mind. Builders used rolling ground that was mapped with shady roadways giving the feeling of cozy intimacy within a context of endless space. The individual monuments mirror

those left behind; they serve as public displays for religious views, expressions of love, and wealth. Despite the earnest emulation America's builders engaged in, one aspect of Europe's cemeteries did not quite take root. Americans have not used their cemeteries as thoroughly as the French or Italians. The earliest garden cemeteries were visited and enjoyed for perhaps one or two generations before Americans decided that constant contact with death did not suit their relentlessly optimistic natures. Americans do not picnic, rendezvous, or make love there as do the Parisians. This refusal of European practices may have been a consequence of the urgency and complexity of settling a new country and the constant western movement that made looking back an impractical impulse. In any case, most twentieth-century Americans do not consider the cemetery a part of their everyday lives. The invention of "memorial parks," with their manicured grounds and look-alike markers, laid flat so that they can be mowed over by wide-swath lawn care systems, has not helped the situation. There is evidence of a renewed interest in historical and artistic burial grounds, and that interest may eventually help to partially save the modern cemetery from the same mentality that gave us postwar urban renewal.

## The Heartland Cemetery

As European settlement spread across the continent, traditions of burial and memorializing followed and adapted to new conditions. Most immigrants left families behind and, as miserable as things might have been in Italy or Ireland, a fragment of ritual or a familiar old country artifact could go a long way toward easing the feelings of vulnerability on an enormous and undeveloped frontier. The loss of a loved one magnified feelings of insecurity, making it more likely that the family would fall back on comforting words and images. We still have a rich collection of Old World monuments across the Heartland.

Is the Heartland cemetery unique? Perhaps not in terms of encompassing unique artifacts or traditions, but its ongoing pluralism is surely second to none. Most who live in this region would no doubt point to this diversity with pride, noting that while assimilation has taken place over the past one hundred and fifty years many people in the center of the nation have managed to stay in touch with their roots. This cultural variety can be seen in cemeteries from Indiana to Colorado.

The Heartland cemetery is, as you might expect, full of religious imagery—from the austere Lutheran markers of the northern plains to the passionate Hispanic folk art of Colorado's San Luis Valley. Stern verse and unbending scripture on limestone tablets warn us not to stray from the straight and narrow, while nearby a free spirit proclaims a relationship with God that he invented from scratch. Still others pass away with only a nod of respect to the mystery of it all. These theological viewpoints, and many more, can be seen in in cemeteries in cities and towns that cling to I-70 and I-80, the busy interstate highways that cross the Heartland, as well as in counties that support less than a thousand people. Convention prevails in a certain percentage of memorials and, as in any human endeavor, some things are simply done by default. When carefully explored, however, almost any Heartland cemetery can give you an intimate and detailed accounting of its people's spiritual impulses, be they conventional or eccentric.

In places like Denver's Fairmount Cemetery or Chicago's Graceland, monuments by Italy's best artisans crowd along the roadway. Eyes roll heavenward and straps fall from the shoulders of nubile surrogate mourners. Italian artists have often coupled death with seduction. In Viterbo, Italy, one cemetery sculpture depicts death kissing a swooning maiden whose gown has fallen down around her waist. Another maiden, in Genoa, is still conscious and resisting the predatory, skeletal embrace. In puritanical America, these parallels are kept more subtle, but there are erotic touches in almost any wealthy urban cemetery where imported monuments are likely to be found. Pouting or distraught cherubs are also used as surrogate mourners, making the loss of a loved one seem like a cosmic event, a source of sorrow even for heaven itself. In England, dogs are used in this same role. This phenomenon is rare in the United States but it does occur, complete with sculpted anthropomorphic tears that fall from the animal's eyes.

Homegrown artisans organized large, flourishing workshops in places like Bedford, Indiana, and Pittsburg, Kansas, and there created images of uncomplicated grief that seem more innocent than those produced in Europe. On treeless prairies along the Ore-

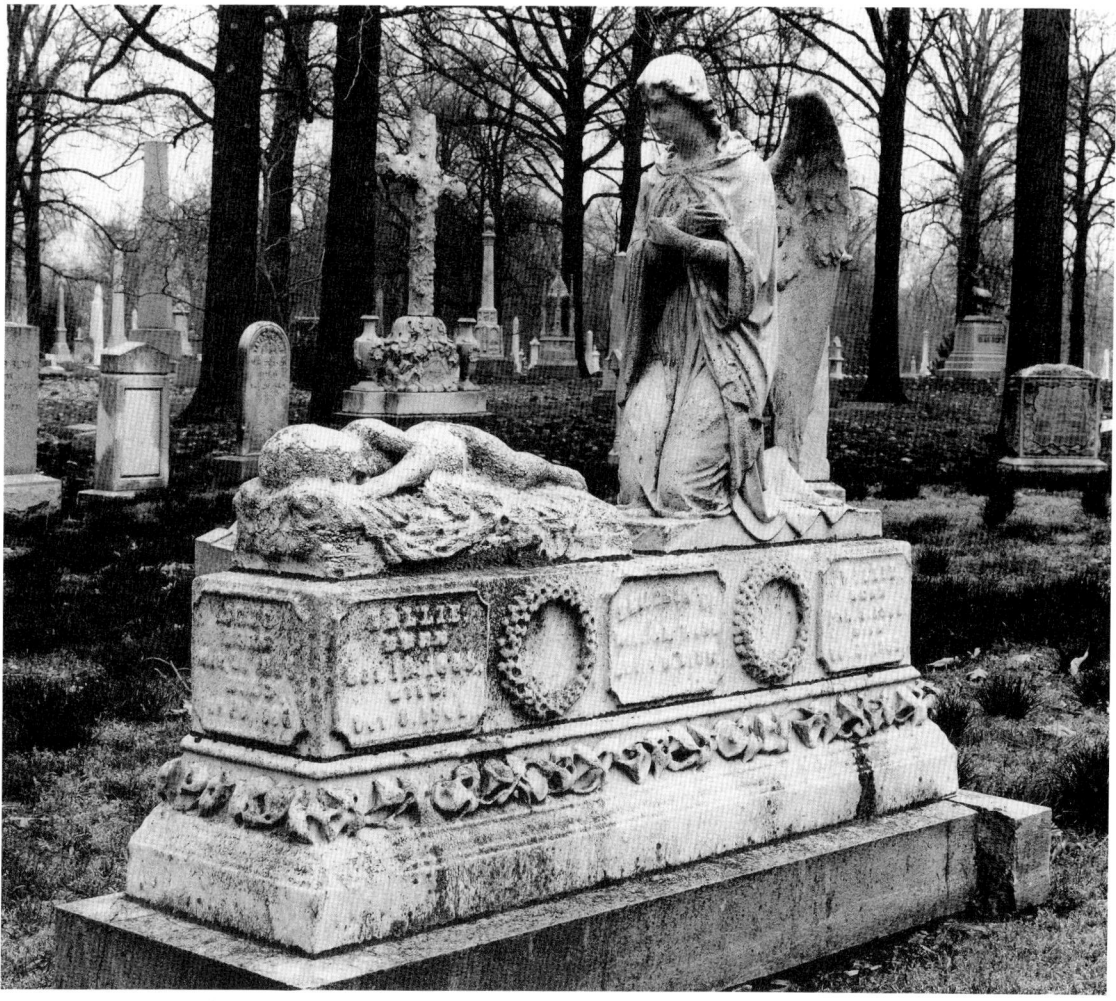

Bellefontaine Cemetery, St. Louis

gon Trail, migrating families did their best with the limestone that was used to make fence posts as well as hastily rendered tombstones. Small country cemeteries reflect the modest but established lives of farmers, filling the gap between the rude migratory burials and the opulent monuments of the city necropolis.

Materials used to create monuments varied with the conditions, locations, and times in which they were made. Limestone was the most commonly used stone in the time of the pioneers, although marble was quarried in Colorado and the Midwest and had found its way into surprisingly obscure locations by the late nineteenth century. The limestone quarries of Bedford, Indiana, were well known, and sculptors preferred to work with Bedford stone whenever possible since it had an even grain and was easy to carve. In Bedford's Greenhill Cemetery, the visitor can see a gravestone sculpture of a man with his set of golf clubs, ready for an eternity of leisurely driving and putting. Not far away, one encounters a limestone facsimile of the workbench of a local stone cutter, complete with all the unfinished projects that his fellow workers found shortly after he was killed by lightning. In Clear Creek Cemetery, south of Bloomington, the tombstone of E. C. Douthitt features a perfect limestone anvil and hammer. In Jasper, Indiana, the monument to Michel F. Durlauf, done by his son Leo, takes the form of a six-foot log covered with ferns, ivy leaves, oak leaves, an axe, chisels, and a double-pointed sledge or "scabbing" hammer, as well as a lyre to commemorate participation in a community band. Limestone was a way of life and a way of death around Bedford. Monuments done in limestone and marble form a rich collection of American portraiture, especially of ordinary people engaged in everyday pursuits. The Heartland work ethic and the joy of play can be seen where the bereaved had access to skilled sculptors and fine materials.

In other parts of the Heartland, many local varieties of limestone were quarried and used when the best could not be obtained or was not deemed necessary. Wood, if available, provided a material that could be worked quickly if death occurred in harsh weather or when a family was on the move. Also, wood or wrought iron were occasionally chosen when a family could not afford to purchase costly stone. Wooden or iron fences were sometimes placed around the grave site as decorative elements and to protect the plot from unwelcome disturbance. Sandstone and slate were utilized in areas where they were readily available. Granite, the hardest of all stone that is routinely used for monuments, was difficult to quarry and sculpt in the early days, but is now nearly universal in conventional tombstones because of its legendary durability. Its hardness usually dictated a simple image, such as prosaic lettering or low relief, pictorial motifs. Even when skillfully carved, it lacks the warmth of marble, but granite monuments erected at the turn of the century are virtually unchanged after nearly a hundred years of exposure to the harsh seasons that batter the center of the United States. Marble or limestone from the same period usually shows serious deterioration unless somehow protected from the elements.

In Pittsburg, Kansas, Hance White operated the Pittsburg Marble Works and did some moonlighting as a sculptor and a musician. His company imported marble and granite from quarries in the United States and abroad, producing monuments that varied from simple headstones to a costly granite sarcophagus. White personally carved many tombstones, including a strange, haunting child kneeling in prayer that can still be seen in the Pittsburg cemetery. He also built his business into a highly successful empire, opening a

branch of the company in Miami, Oklahoma, but he still found time to play several instruments, including the organ at the local Methodist church.

Area foundries produced bronze, usually for detailing or portraiture. When that was too expensive, pot metal was used. Later, concrete found its way into the list of materials and became a favorite of folk artists, who could stick glass, ceramic fragments, or marbles into the wet cement and produce a kind of poor man's mosaic. Many Hispanic markers in southern Colorado and northern New Mexico use a variety of other materials set into concrete, such as telephone insulators, marbles, decorative metal, ceramic fragments, sea shells, plastic bottles or toys, and polished rock slices. Charms resembling voodoo mojos fashioned from rubber, string, wire, tape, or fabric were hung from tombstones. Wrought iron crosses are still fairly common in areas where German or Scandinavian immigrants settled. Swedish crosses sometimes feature small iron artifacts in the form of hearts or geometric shapes that dangle from the arms of the cross and tinkle softly in the wind. Cast iron or pot metal markers with decorative bases can be found where French or Bavarian people predominate. In Lincoln, Nebraska, when a pioneer flier crashed and lost his life, his shattered propeller was put up to mark his final resting place. In the 1920s, an entire car engine was used for a grave marker.

Many new cemeteries are made flat and featureless by design for easy maintenance, but most classic Heartland cemeteries were placed on hills or ground that was romantic in appearance but difficult to farm. Roads were built according to the lay of the land and to save whatever trees occurred naturally on the site. This is usually the case with large urban burial grounds and sometimes with the picturesque hamlet graveyard, which often held no more than twenty or thirty graves. While Catholic, Protestant, and Jewish citizens often shared the same cemetery, they were, and are, usually segregated by belief. Separation was not always voluntary, and the racial segregation of African Americans after death merely continued practices among the living.

Organizations such as the Masons, their sister organization the Eastern Star, the Elks, the Rebekah Lodge, and the Independent Order of Odd Fellows traditionally set aside plots of land so that fraternal feelings could continue unbroken into eternity. This type of burial was strictly optional, but many of the St. Louis brothers have chosen to be interred at "Elk's Rest," in Bellefontaine Cemetery. Inclusion of immediate family is usually allowed. The International Order of Woodmen of the World and its sister organization Women of Woodcraft were actually components of a fraternal insurance company that was very active in the late nineteenth century and early twentieth century. The policy paid fifty to a hundred dollars toward the purchase of a tombstone for any policyholder. Their monuments, in the form of sawed or dead trees, or stacks of wood, are very common in older Heartland cemeteries. These ubiquitous images provided the company with ongoing and very durable advertising. The organization's motto, "When silent, he speaks," also appears on many gravestones.

The tree stump monument became an important motif in Heartland cemeteries, and the use of this image did not always indicate a member of the Woodmen group. Stone tree trunks or stumps, ranging in size from fourteen inches to almost twenty feet, provided a dramatic metaphor for the pain of loss, especially when the death was thought to be premature. The addition of details such as tree fungus made the image more palpable

and the addition of ivy leaves indicated the strength and ultimate triumph of rebirth. Many monuments of this type became extremely elaborate, incorporating elements of religious significance, as well as references to the deceased's vocation and avocations.

In Gosport, Indiana, an 1898 monument to a pioneer couple, Marcus and Malinda Smith, takes the use of this motif to its most grandiose and esoteric application. The stone carvers, brothers Silvester and Claude Hoadley, were asked to build a monument to the Smiths and to make references to their pioneer status, as well as their well-known piety and generosity. Along with the usual detailing of ivy leaves and mushrooms, this monument features two groupings of objects that are associated with the departed couple and pioneer society in general. Malinda and the female pioneers are represented by a spinning wheel, a reference to domesticity and industry during those homespun times, while Marcus and the men are identified with an axe, a maul, and a splitting wedge to celebrate the clearing of the wilderness. On the other side of the tree trunk sits a pile of books. A hand reaches for the topmost book, a Bible, indicating the couple held the Bible in the highest regard and read it often. Near the top of the tree, a vignette shows one hand passing an object into another hand. According to locals, this object is a biscuit that symbolizes the famous generosity of the Smiths.

Soldiers, fire fighters, police officers, circus performers, actors, railroad workers, and even motorcycle gangs have chosen to stay together after death. Catholic cemeteries often reserve special sections for clergymen, whereas Protestant burial grounds generally scatter them throughout the general population, reflecting a more democratic viewpoint. Protestant preachers are often featured in specific portraits, emphasizing the importance of the individual, while Catholic monuments tend to look more dutiful and hierarchical. The bishops provide a focal point, and those of the next highest rank are interred nearby. The importance of celibacy among Catholic clergy also eliminates any sense of the worldly family from those monuments.

As in life, public servants such as police officers or fire fighters sometimes prefer the anonymity and collective expression of identical tombstones. At Denver's Fairmount Cemetery, the visitor can gaze upon the memorial for the "Hook and Ladder Company," which later became the Denver Fire Department. The illustrated monument showing the primitive equipment with which these brave men fought major blazes is sobering, and it overlooks several individual graves, which are minimally and uniformly marked. In the case of soldiers, identical tombstones are usually mandated, although overlooking the site there is often a very elaborate sculpted monument commemorating a specific battle or fallen soldiers from a certain geographical location. Among the sculpted flags, cannons, and smoke there is often a heroic figure accepting a laurel wreath from a scantily clad female angel and a bronze plaque detailing the mayhem. In Aspen, Colorado's, old cemetery, a turn-of-the-century labor leader named Waite is commemorated by the Western Federation of Miners, reminding us that before Aspen was a resort for the beautiful people, it was a silver-mining camp that presided over violence and hardship. In Lincoln, Nebraska's, Wyuka cemetery, engineer Walter Dameron is remembered with specific information: "Killed in wreck on Burlington Railroad, near Indianola, Nebraska." An etched image of a locomotive looms above another inscription: "Be ye also ready for such an hour, as ye think not the son of man cometh."

Many secret societies guard their rituals and handshakes as if they were state secrets, but the Benevolent and Protective Order of Elks were remarkably forthcoming when I asked them to explain the meaning of the clock that always appears on a brother's tombstone above the antlers of the ubiquitous Elk. The clock always indicates the eleventh hour, and it is easy to link this image to the hourglass, which gently reminds us to get our affairs in order. The official explanation of the eleventh hour in Elkdom, however, is a bit more multilayered:

> When the clock strikes eleven, the exalted ruler calls for darkness and silence. He says, "It is the hour of recollection. My brother, you have heard the tolling of eleven strokes. This is to impress upon you that, with us, the hour of eleven has a tender significance. Wherever an Elk may roam, whatever his lot in life may be, when this hour falls upon the dial of night, the great heart of Elkdom swells and throbs. In the golden hour of recollection, the homecoming of those who wander, the mystic roll call of those who will come no more. Living or dead, an Elk is never forgotten, never forsaken. Morning and noon may pass him by, the light of day sink heedlessly in the west, but ere the shadows of midnight shall fall, the chimes of memory will be pealing forth the friendly message to our absent brothers."

Many larger cemeteries will, on request, give visitors an informational pamphlet. The map that is usually included will help locate "Tennessee" Williams in Calvary Cemetery, St. Louis, Missouri, or General William Clark, of "Lewis and Clark" fame, across the street in Bellefontaine. Mount Mora Cemetery in St. Joseph, Missouri, will point the visitor toward the graves of Pony Express riders or the Civil War Confederate general known as the "Missouri Swamp Fox." Very few of the illustrious personages pointed out in the various cemetery pamphlets are included in this book's illustrations, however, since the emphasis here is on visual and psychological elements rather than the historical. Biographical information that can be gleaned from Heartland tombstones will vary from the "Davis Memorial" in Hiawatha, Kansas, which features beautifully detailed marble and granite portraits of a husband and wife at virtually every stage of their lives together, to a worn tablet in Nebraska City, which reads simply, "Willie."

Modern tombstones have recently shown signs of becoming interesting. Since the decline of the romantic eras associated with Art Nouveau and Victorian excess, and setting aside the brief and interesting blip that corresponded with the Art Deco movement, American tombstones have descended into dullness. They became look-alike granite bookends during the Great Depression and then flat, 1950s plaques that lay submissively beneath the blades of enormous lawn mowers. The stone cutter and sculptor lost the ability to produce in-the-round marble statues or even custom images. Those left in the business simply operated machinery and chiseled out names and dates on the multicolored granite. Even those who could afford to have real works of art hovering over their loved ones were convinced that less was more. Perhaps it seemed inevitable, or even desirable, in an age of stainless steel and glass cities.

Most modern gravestones are still polished granite blocks, but a new interest in photographic stencils, used with sandblasting and lasers, has enabled the contemporary monu-

ment salesman to offer illustrations based on photographs, drawings, or handwritten messages. It is now easy for one's tombstone to feature a car or sewing machine, an idyllic landscape, hunting or fishing scenes, musical images, or a cowboy and girl riding off into the sunset. While it would be overstatement to call these new developments universally fashionable, it is nonetheless heartening to find that they are now at least an option. The development of the means to produce individual monuments indicates a new willingness to acknowledge our mortality. A beautifully detailed, in-the-round granite Mercedes-Benz was recently produced for one high-rolling dear departed. In Truchas, New Mexico, a young man is remembered by two "chopper" V-Twin motorcycles, fashioned with a cutting torch and then welded into place, alongside the traditional wooden and sandstone crosses. Actual photographs or delicate, hand-painted copies, affixed and baked onto convex enamel or porcelain ovals, are making a comeback, as are personalized inscriptions. These days they are likely to say, "A free Spirit," or "I'd rather be drag racing," instead of the traditional epitaphs. In Fort Wayne, Indiana, Archie Arnold's last request was to have his tombstone flanked by two actual parking meters, each displaying its "expired" flag. "You had to know Archie," his lawyer explained, and because of this humorous and creative gesture, in some small way we all do know Archie.

Lawrence, Kansas, is home to the University of Kansas "Jayhawks," who have won many basketball championships since the game was invented in 1891 by Dr. James Naismith. Naismith later coached basketball at Kansas and was succeeded in that role by basketball legend Dr. F. C. "Phog" Allen. A memorial to James Naismith at the Lawrence Memorial Park features a sculpted portrait which stands in the free throw lane, in the midst of a monument which is configured to resemble one end of a basketball court. Beyond the location of the invisible "basket," an expanded courtyard features tributes to Allen and other basketball greats who are associated with Kansas.

It sounds foolishly obvious to say that the Heartland cemetery, a repository for death, can reveal and illuminate much about life in that area, but this cliche may be inescapable. The lessons to be learned among the headstones are both singular and universal.

## Outstanding Burial Grounds

Although many interesting tombstones can be found in small cemeteries, hidden within rows of dull look-alike granite blocks, some older urban sites can give the visitor more predictable rewards.

Graceland Cemetery, in Chicago, Illinois, is perhaps the richest single site in the Heartland, possessing extraordinary individual monuments as well as the graves of many famous and influential people. It also has a wonderful ambience resulting from the mixture of Victorian excess and nature's grandeur. The cemetery was founded in 1860 by Thomas A. Bryan and immediately became a magnet for the earliest settlers as well as the elite of Chicago society. Outlandish mausoleums in Egyptian, Gothic, and Greek styles line the roadways, infusing the memories of the dead with shadowy manifestations of the power, fame, and wealth with which they lived their lives. They also provided opportunities for important architects and artists to express themselves.

Sculptor Lorado Taft is responsible for two impressive monuments in Graceland, a granite knight that marks the resting place of Victor Lawson, father of the *Chicago Daily News*, and a terrifying bronze "Death" that overlooks the Graves' family plot. Architect Louis Henry Sullivan designed several of the elaborate mausoleums, including the Egyptian-style crypt for Martin Ryerson that is finished in black granite and a tomb for the Getty family that Frank Lloyd Wright described as "entirely Sullivan's own, a piece of sculpture, a statue, a great poem." This monument, which sits at the edge of Lake Willowmere, was built in 1890 and designated a Chicago landmark in 1960. On the island that sits in the middle of the lake, the monument to Daniel Hudson Burnham celebrates his extraordinary contributions to architectural and city planning, including the design for the 1893 Columbian Exposition. Sullivan is buried in Graceland beneath a modest stone.

Also buried at Graceland are Bob Fitzsimmons and Jack Johnson, famous heavyweight boxing champions; Allan Pinkerton, namesake founder of the Pinkerton Detective Agency; and George Pullman, inventor of the Pullman train car. Reportedly, Pullman's body is entombed in an incredible complex of protective measures, including a coffin which is wrapped in tar paper and then floated in concrete, all within a room-sized chamber. This compulsive system rivals that of the pharaohs and may betray an extreme fear of desecration, or merely fear of the natural processes of decay. In any case, it is one more aspect of the mystery that makes up our collective response to mortality.

For the most part, illustrious lives seem to end with visually ordinary tombstones, so few famous people are included in the illustrations of this book. The use of understatement may have come from the dynamic of fashion in monument building. The romantic excess that came to be known as the "Victorian celebration of death" was for several decades the mode of expression solely of the wealthy or the extravagant. Elaborate monuments were accompanied by expensive mourning clothes and accoutrements that were used in a period of extended grieving and protracted ritual. With the dramatic improvements in the standard of living that occurred in the late nineteenth century, it was suddenly possible for farmers or factory workers to participate in this phenomenon, and they joined the process enthusiastically. At that point there was nothing for the social elite to do but make a virtue out of understatement, and it was soon decreed that opulent display was to be seen as vulgar. In the same way that the rich began to reject the old posturing, the famous, whose deeds had been etched into the public consciousness, sought the modest or simple monument as a sign of virtuous humility. By the advent of the twentieth century, household names were likely to rest under artistically understated monuments. There are, of course, notable exceptions. One is the tombstone of William A. Hulburt, one-time president of baseball's National League. The large granite baseball that marks his grave is beautifully detailed, including sculpted stitches and the names of the cities that comprised the league at that time. Nearby, the cryptic Morrison tombstone is decorated with a relief illustration of the Latin words "Rex" (king), "Lux" (light), "Lex" (law), and "Dux" (leadership) in a kind of Greek cross configuration. These words overlook a sculpted canoe, which floats the family name below. This stone is one of many entertaining minor mysteries hidden in Graceland's labyrinths.

Although not as large or well known as Graceland, Chicago's Rose Hill Cemetery is full of inventive and beautiful monuments. Especially entertaining is the grave marker of

George S. Bangs, who developed the railroad mail car. It is a crisp and detailed sculpture of the mail car, disappearing into a tunnel and overlooked by an attached tree trunk. As in most tree trunk monuments, the "bark" is peeled back to reveal a smooth surface on which names and dates can be inscribed. George's inscription reads: "His crowning effort—the fast mail." Also interesting is the enormous obelisk erected by "Long" John Wentworth, Chicago's twenty-first mayor. Mayor Wentworth was six feet six inches tall and he was determined to have Rose Hill's largest monument, so he ordered, in advance, a colossal obelisk that stood seventy-two feet high, on a base that weighed fifty tons. An investment of $38,000 ensured that his monument was indeed the most grandiose within the walls of Rose Hill.

In Evanston, Illinois, at the north edge of Chicago, a Catholic cemetery called Calvary overlooks Lake Michigan. This cemetery is the Chicago area's largest and is a repository for the city's earliest history. Early settlers, several mayors, and governors are buried in Calvary, along with 300 priests and over 800 nuns. In general, Catholic cemeteries give one the impression that the dead would prefer to be remembered as "good soldiers," and this site is no exception. The appeal of Calvary is mostly cumulative and collective. There are not as many outstanding individual monuments as can be found at Rose Hill or Graceland, but the graceful landscaping, the location next to the lake, and the unique insulation from the city make this site a joy to visit.

Bellefontaine Cemetery in St. Louis, Missouri, covers 327 acres of rolling ground and is full of superb monuments, from the Wainwright mausoleum, by Louis Henry Sullivan, to the modest but lyrical tablets of the ordinary citizens of this river city, which linked the developing West with Mississippi River commerce. Several gravestones belonging to riverboat captains are scattered throughout Bellefontaine's older sections, including some that are decorated with images of the paddle wheel vessels. One stone features a portrait of Captain Isaiah Sellers at the wheel of his river boat.

The cemetery was incorporated in 1849 and many of the outstanding monuments depict pioneer themes, reflecting the optimism and expansive spirit of the nineteenth-century frontier. The avenues that meander organically over the site are all named for botanical images—Cypress, Myrtle, Red Bud, Wildwood, Woodbine, and so forth. Even the separate hills are named—Magnolia, Mulberry, and Locust, as well as the obligatory and romantic lakes, which are called "Cascade" and "Cypress."

Although Bellefontaine is appealing chiefly for its beauty, there are many historical figures interred within its boundaries. General William Clark traveled north and west with Meriwether Lewis, mapping and exploring the upper Louisiana Territory for over two years, ending finally at the Pacific coast. Lewis was mysteriously murdered on his way to Washington, where he intended to report the results of the expedition. Clark remained in St. Louis and became the Indian agent for the Missouri Territory. He died in 1838, but the sprawling monument that now stands at his grave site was unveiled in 1904 during the World's Fair celebration. Although it cost $25,000 to erect and features a bronze bust by William Ordway Partridge, there are modest stones and Celtic crosses nearby that are considerably more interesting and touching.

Poet Sara Teasdale, who won the first Pulitzer prize ever awarded for poetry, is buried beneath a simple stone at Bellefontaine. Adolphus Busch, who married Lily Anheuser and

began what is now the world's largest brewery, lies in a magnificent Gothic mausoleum. The tomb, which resembles a small church, is built entirely of red granite and roofed with green slate.

Another brewer, Ellis Wainwright, commissioned Louis Henry Sullivan to design a mausoleum for his beautiful young wife, Charlotte Dickson Wainwright. Sullivan had just finished the Wainwright Building, one of America's first "skyscrapers" and an architectural masterpiece. The mausoleum became known as the "Taj Mahal of St. Louis" and eventually was listed on the National Register of Historic Places.

Most intriguing of all the opulent Bellefontaine monuments, however, is the one to Herman Luyties, a St. Louis druggist. During a trip to Italy in the early 1900s, Luyties met a beautiful sculptor's model and fell in love with her immediately. His proposals of marriage were spurned and he prepared to return to America, broken-hearted. Before he left Italy, however, he commissioned the model's employer to sculpt a portrait of her that could be shipped to his home in St. Louis. The enormous statue was kept in the foyer of his house, until fears about possible damage to the structure prompted the family to relocate it to the cemetery plot in Bellefontaine. When lovesick Herman Luyties finally died at the age of 50, his remains were buried at the foot of what became known as "the girl in the shadow box." An almost identical statue, obviously modeled for by the same girl, stands in a cemetery in Viterbo, Italy. The only difference between the two pieces is the addition of angel wings on the Viterbo version. Since this sculpture was accidentally discovered by the author, it seems likely that many other variations might exist throughout Italy and other locations in Europe. Many sculptures that proved to be popular with clients and the public were reproduced by the original artist or copied by imitators.

Mainstream achievement is mixed with sordid folly at Bellefontaine. One of the founders of Bellefontaine, William Bennett, built a stone canopy to protect the sarcophagus of his wife, Kate Brewington Bennett. In the 1850s, Kate was considered to be one of the most beautiful women in St. Louis. In order to maintain the fashionable pallor that was considered attractive in those days, Kate took small doses of arsenic and eventually died from the cumulative poisoning. Not far away, Susan Blow, founder of the first kindergarten, is buried, as is her father, Henry Blow, a member of the administration of President Grant.

As if this weren't enough, the Catholic cemetery across the street, Calvary, is full of beautiful sculpture and notable personages, ranging from writer Tennessee Williams to General William Tecumseh Sherman. Visually, the most impressive memorial at Calvary is the Morrison family crib monument, which consists of a pair of beautifully rendered marble statues that show two sickly children, one in a crib, the other in a wheelchair. The wheel spokes are ritually broken by the sculptor to indicate broken lives, and the children's faces are haunting, full of uncomprehending terror. A marker of this intensity is highly unusual in the United States but can be seen with regularity in European cemeteries. The Morrison crib monument is reminiscent of one that can be found on the dark hillside of Genoa's Staglieno cemetery, which features a life-sized bronze child who is running and rolling a hoop, unaware of the gnarled hands of death, which reach out of the ground to grasp him from behind.

Crown Hill Cemetery, in Indianapolis, Indiana, is the resting place for three men who

served as vice president of the United States and three who ran unsuccessfully for that office. Twenty-third president Benjamin Harrison is interred behind the grandiose Gothic gates. Crown Hill was founded in 1864 and was not ready for burials until several months after the death of Caleb B. Smith, Abraham Lincoln's secretary of the interior. The mausoleum, which bears Smith's name and the date of his death, does not and never did contain his remains. During the interval between his death and the opening of Crown Hill, his body was placed at Greenlawn Cemetery, in an unauthorized mausoleum which was ruled "unsanitary" and ordered torn down. His widow subsequently built another tomb, in which she and her daughter eventually were placed, but Caleb Smith's body disappeared, some say to the family home, some say to Cincinnati and, for all practical purposes, to oblivion. His memory can still be honored at Crown Hill but his true whereabouts remain a mystery.

Indianapolis was a mecca for Union volunteers and a center of passionate anti-Confederate feeling during the Civil War, and the spacious military burial ground attests to the scale of the sacrifice. Men flocked to Indianapolis from small towns and farms, and eventually over 200,000 enlisted. The site for this memorial was actually purchased from Crown Hill by the War Department, so it is a cemetery within a cemetery. Among the thousands of dead are thirty-six unknown soldiers.

Hoosier poet James Whitcomb Riley is laid to rest at Crown Hill, as is W. H. H. Terrell, a bureaucrat who worked for Indiana Governor Oliver Perry Morton. Morton is now remembered only by the poem which Riley penned for him and published in the *Indianapolis Journal* in 1884:

> I cannot say and I will not say
> That he is dead. He is just away!
> With a cheery smile and the wave of the hand,
> He has wandered into an unknown land,
> And left us dreaming how very fair
> It needs must be, since he lingers there.

At the western edge of the Great Plains on the eastern slope of the Rocky Mountains, Denver's Fairmount Cemetery holds many of the pioneers who pushed west from Missouri and Kansas, extending the frontier further. Here too, within the 640 acres, are buried the predictable overachievers and prime movers in law, medicine, politics, and the clergy. A little investigation, however, will reveal part of the dark side of America's development. Colonel John Chivington, a Methodist preacher and military man, is credited with helping to win the western front of the Civil War, but he is also remembered as the commander of a regiment of soldiers who surprised a peaceful Indian encampment and butchered hundreds of women and children. This incident, which was condemned even by expansionist zealots in Congress, became known as the "Sand Creek Massacre." The murder and mutilations earned Chivington a place in infamy and guaranteed another decade of war between Indians and settlers. Not far from Chivington's monument, the graves of Nathan Hungate, his wife, and their children are marked by a single stone which reads: "Killed by Indians, 1864." It is possible that John Chivington could take partial credit for those deaths.

Cattle baron John Wesley Iliff is interred at Fairmount, along with influential pioneer W. A. H. Loveland, railroad visionary David Moffat, and Wolfe Londoner, Denver's only Jewish mayor, who claimed to have discovered the ruin of an ancient civilization in the mountains to the west. A feud with the National Geographic Society developed when they publicly questioned the claim. Several years later, after the cliff dwellings at Mesa Verde were officially "discovered," Londoner had the last laugh.

Most city cemeteries that have been in existence for at least one hundred years will offer the visitor an interesting sampling of Heartland monuments. In Chicago's Oak Woods Cemetery there are monuments to the firemen who lost their lives while fighting the great Chicago fire of 1871. There is even one memorial constructed from twisted metal and glass taken from the remains of the cemetery's office, which was located downtown.

Woodland Cemetery in Des Moines, Wichita's Maple Grove, and Forest Hill Cemetery in Kansas City are examples of burial grounds which reflect the quality of local life as much as the acknowledgment of death. Cemetery hopping in Kansas City, Missouri, is great fun. Mountain man Jim Bridger is remembered at Kansas City's Mt. Washington Cemetery by a large granite monument, which features a relief portrait of the famous explorer, plus a brief biographical list of his exploits, which included the "discovery" of the Great Salt Lake for the hordes of white settlers who would soon follow and the discovery of the area that is now Yellowstone Park. A few minutes away, in Elmwood Cemetery, the visitor can pay his respects to infamous "madam" Annie Chambers. Charlie "Yardbird" Parker, only one of many Kansas City jazz greats, is buried at Lincoln Cemetery.

The tombstone for Leroy "Satchel" Paige, one of baseball's all-time greatest players, utilizes crossed baseball bats as an illustration, which is odd since Satchel was a pitcher for most of his career. The tombstone, located in Kansas City's Forest Hill Cemetery, also features an unusual statistic, or lack of one. Nobody knows exactly when Paige was born. He explained that his birth certificate was in the family Bible and the goat ate the Bible, so the inscription below his name reads: "?- 1982."

Hannibal, Missouri, was Mark Twain's childhood home and many of the Clemens family are buried in Mount Olivet Cemetery, located there. Famous Indian fighter Kit Carson is buried in the cemetery in Taos, New Mexico, which is named after him, but nearby Hispanic cemeteries, such as Truchas and El Prado, are usually more artistically interesting. The ghoulish and nihilistic can hunt for gangster John Dillinger's grave at Indianapolis, Indiana's, Crown Hill, gaze at the bland and pious monument for Kansas City gangster John Lazia, in Mt. St. Mary's Cemetery, or shudder at the simple stone of mass murderer Charles Starkweather, in Lincoln's Wyuka.

Eventually, however, the true enthusiast will have to go far afield, to the tiny graveyard at Chilili, New Mexico, where folk artist Horace McAfee welded and bolted together monuments for his family and neighbors that look both hauntingly beautiful and repelling. One has to go to Garden City, Kansas, to see the car engine monument, or to the hamlet of Attica, Kansas, to read a tombstone tirade against the Democratic Party. Looking for the real Heartland in its cemeteries is a fascinating series of plateaus, beginning with the gigantic city necropolis and ending, perhaps, with the sunny weed-grown hillside above unmarked county roads.

Creede, Colorado, is a small former mining community that exists on a short tourist

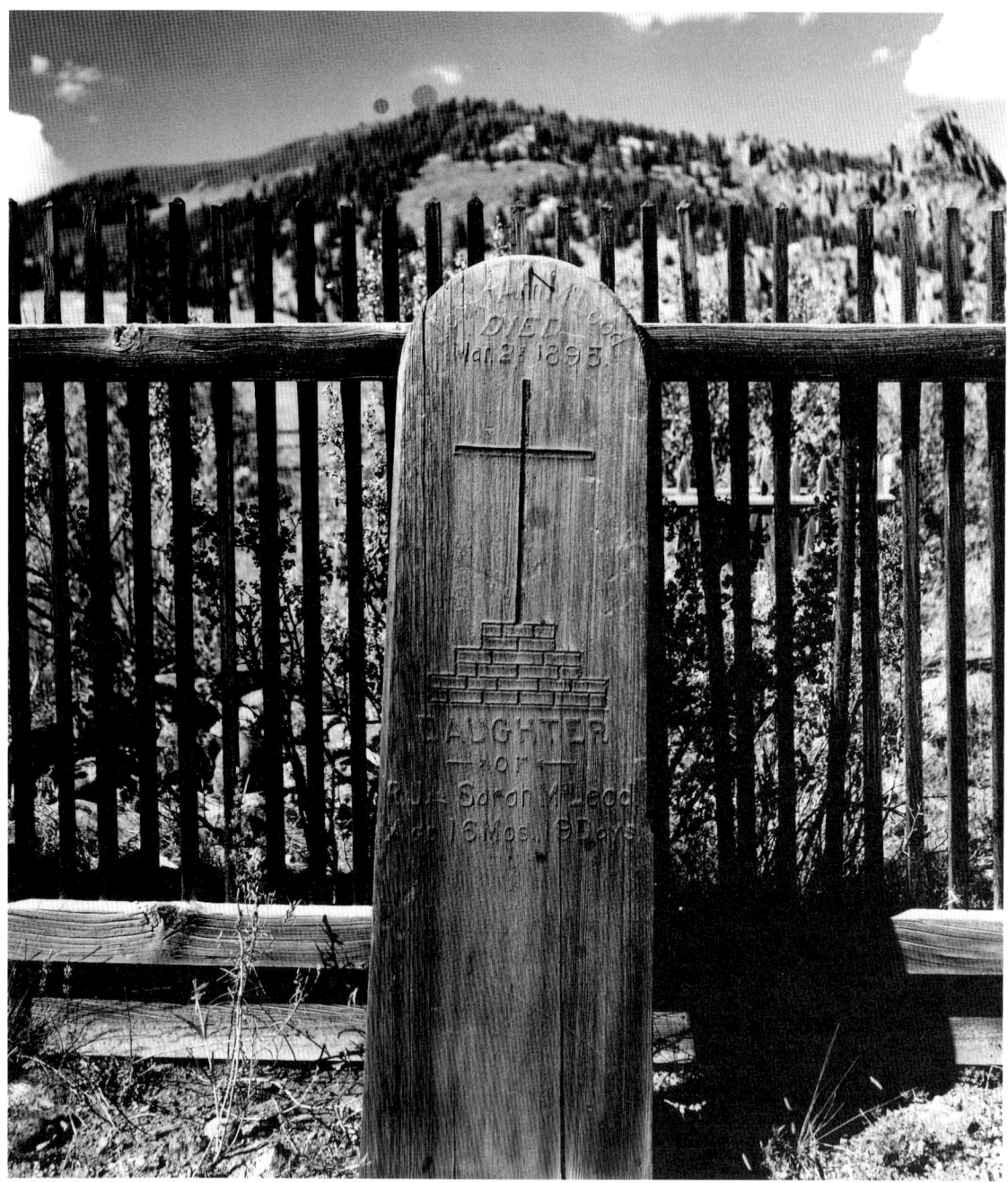

Wooden marker, Creede, Colorado

season and the improvisational creativity of its five hundred or so permanent residents. The cemetery was established during the boom that accompanied Colorado's silver mining spree of the late nineteenth century. Now, as then, burial in the Creede city cemetery is free of charge, except for the opening and closing of the grave. In the 1890s Creede had a population of ten thousand souls and nearby Bachelor had two thousand. Originally there were two cemeteries in Creede—one for respectable citizens and another for gunfighters, criminals, and professional ladies of dubious character. At the height of the silver

18 / *Soul in the Stone*

mining boom, three hundred people a day arrived and ran up into the mountains, digging unproductive "glory holes" alongside the few really big strikes. Bat Masterson, "Soapy" Smith, Poker Alice Tubbs, and a host of small-time hustlers arrived to cash in on the action. Bob Ford, "the dirty little coward" who had murdered Jesse James back in Missouri, moved to Creede at the peak of its frenetic growth and operated a tavern until he himself was slain by another shotgun-wielding ruffian. Bob Ford was buried in the graveyard of ill repute, until his body was later moved back to Missouri. Today all the graves in this area are unmarked, except for the sign that mentions the now absent Ford.

On the high hill which overlooks the town and its spectacular canyon, graves from the 1890s, surrounded by decomposing wooden fences, sit side by side with an interesting variety of more modern stones. Many of the markers within these enclosures are wooden arched tablets with feeble raised letters, barely legible one hundred years after their erection. The cemetery holds a sad collection of stillborn babies and young children who died of typhoid, diphtheria, or pneumonia aggravated by the harsh winters and forty-below-zero temperatures. An old Woodman of the World limestone tree trunk honors the memory of Richard Daugherty and brandishes the Woodman coat of arms, which reads "Dum Tacet Clamat" (when silent he speaks). An early stone marker, carved for W. Bryan La Fon, who lived only from 1900 to 1901, features this bleak little rhyme:

> Another little lamb has gone
> To dwell with him who gave.
> Another little darling babe
> Is sheltered in the grave.

Clifford La Fon, who lived for seven days in January 1904, is remembered nearby:

> Our darling one has gone before,
> To meet us on the blissful shore.

The La Fons reportedly decided later that their family name didn't sound "American" enough and changed it to La Font. Their passage is recorded on many stones to follow. Before his death, John La Font would write a comprehensive history of the town and its wild silver mining past, including the story of the night that he himself ate a whole stick of dynamite on a dare. John's wife "Dutch" told fortunes, held Ouija board seances, and cooked "Rocky Mountain oysters" for the endless trail of guests that called at the house. John and Dutch rest near the top of the hill, not far from the Birdseys and the Hosselkuses and the Fairchilds, families who mined and lumbered in Mineral County for a century. The inscription for miner Francis "Whitey" Miller (1907–1972) is simple but evocative: "Home from the hill. A good miner. A good man."

All across the small cemetery, monuments attempt to portray the relationship between people and their mountain home. Earl Leroy Brown rests beneath a granite stone that pictures a horse and rider beside a pine tree. The absence of Ellis E. Clampitt is symbolized by a saddled but riderless horse. J. Bruno Collerette has his name cast in bronze and affixed to a gnarled piece of bristlecone pine. Near the gate to the cemetery, a white frame "gruft" resembles a classic nineteenth-century chapel and carries only the name "Kainer." Locals tell of the spectacular stained glass windows which surrounded the small interior

until local boys shot them out. The ashes of local miner, rock hound, and historian Al Birdsey are buried somewhere in the Creede cemetery. He wanted no funeral service of any kind, and when the proceedings in 1984 began, a clap of thunder shook the hillside in protest. Charlie Harlan was a Mason, an Elk, and a regular in the local bars. The alcohol-induced wisdom that he regularly shared with everyone who would listen was usually preceded by the phrase, "I'll tell you one thing, pard. . ." and that phrase is inscribed on his tombstone. A sentimental fragment of prose tells of the love between the mountains and Amanda Polly Wilcox:

> God gave us this rugged mountain country, a place of joy, pain, happiness and hardships, where comfort and understanding can be sought, and peace found.

Hubert Stephen Check or his loved ones chose Gibran to express mystical human aspirations that spring from the brotherhood and sisterhood of mortality:

> Only when you drink from the river of silence shall you indeed sing.
> And when you have reached the mountain top then you shall begin to Climb.
> And when the earth shall claim your limbs, then shall you truly dance.

Jimmy Lamb was born into one of the oldest and most colorful families of the area. Jimmy embodied a volatile mix of the old mountain ways with the wild and iconoclastic impulses of the 1960s. He was killed in a freak accident in 1989 and the population of the county doubled on the day of his funeral. Songs were written, stories were told, and on the way to a graveside service, the hearse stopped at the bar he had operated. A toast was given in his honor so he could be late to his own funeral, as everyone always said he would be. A bench sits at the head of his grave, as does a carved wooden guitar with drum sticks attached, made and left by friends who shared his wild life as a member of the "O.M.I. Express," a rock band that still plays and tours in the area. Close to the actual headstone sits an enigmatic, lichen-covered stone and a license plate which reads "musician on tour." Jimmy Lamb selected his own epitaph, reciting the phrase to bemused friends for years before his death. It now appears on his headstone, among all the other tokens of love: "Gentleman Jim, a fair man."

The illuminating qualities that are found in the Creede cemetery are extraordinary, but not unique. Throughout the Heartland, history, passion, and artistic expression are often found in the town cemetery. The humble tombstone, an effective teacher, is available everywhere.

## Motifs and Symbolism

The images and epitaphs placed upon gravestones, and sometimes the the entire monument, represent both private grief and public statements. This visual material denotes at least one of three things: important personal insight or expression; a declaration of religious faith; or prevailing social values, expressed in behalf of the departed and the survivors. Even the blandest of illustrations contain some hint of social ideals or philosophi-

Leadville, Colorado

cal views. Images such as blooming flowers or setting suns endeavor to comfort by emphasizing rebirth and putting death into a context of celestial machinery. Even for the most godless, some solace is gained by a recognition that the universe imposes mortality upon all creatures, without prejudice or malevolence. An emphasis on nature's cycles helps to inspire at least grudging acceptance of the on-going ebb and flow of our existence. Without life, there is no death. Without death, there can be no rebirth. This understanding is an antidote for despair.

Even the seemingly generic symbols for death—the broken column, the inverted torch, the dead and dismembered tree, the spilled flower pot, or the funerary urn—involve us in the collective process of loss. They remind us that we are not being singled out for either extermination or metamorphosis. Past generations and even whole civilizations have surrendered themselves for the sake of the process.

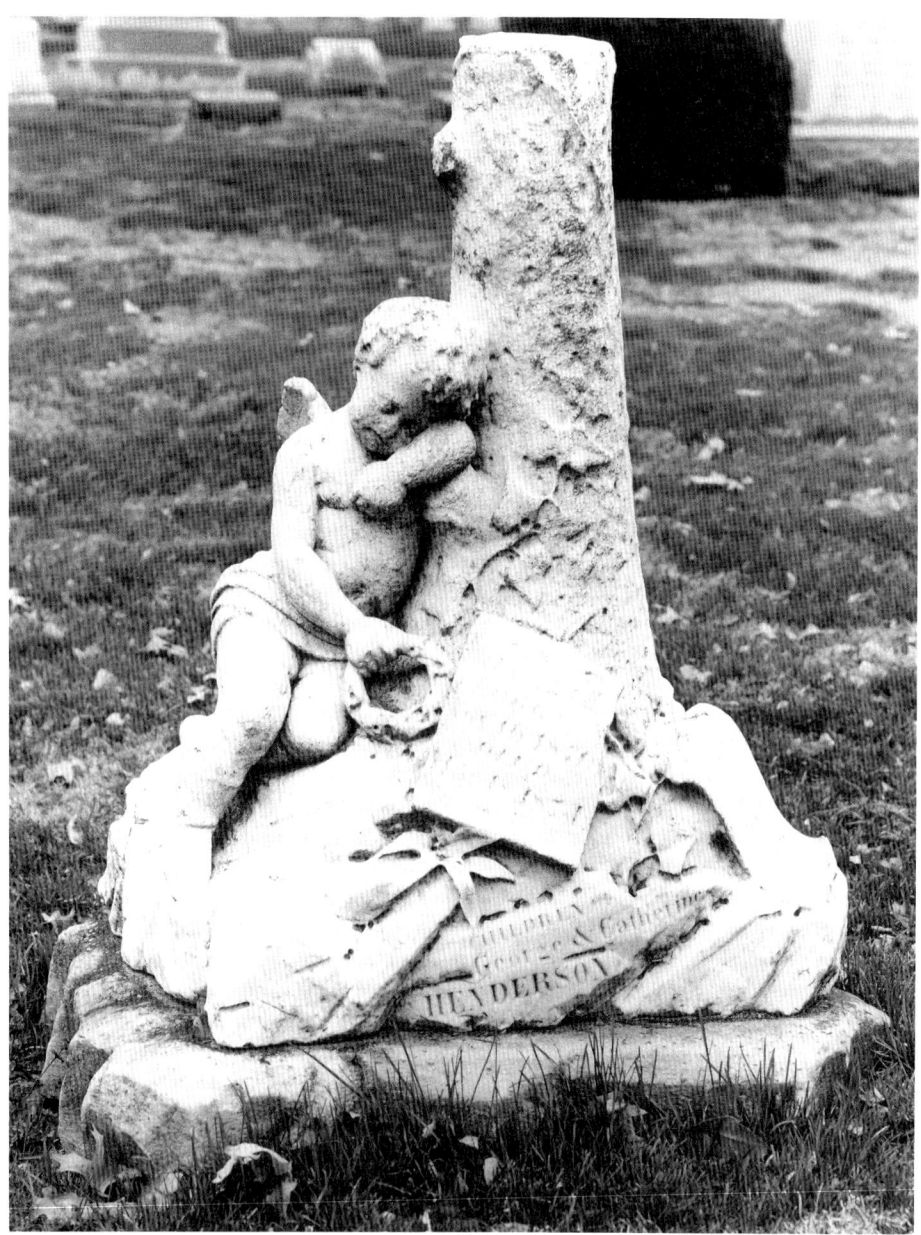

Bellefontaine Cemetery, St. Louis

Within this context, we find a major category of funerary expression: the triumph of the life well lived. For those who believe that life is a finite succession of events and experiences, the ultimate mastery of the human condition is to use that time well. Many monuments point to significant accomplishments by the deceased or indicate legacies left by them to their families or society. Others allude to spiritual advancement or the joy of simple pleasures as indications that the person in question had used his or her years wisely and skillfully. The subject of the stone may be shown fishing in a beloved trout stream. He or she may be represented by a piano keyboard or a traveling salesman's suitcase. Examples already mentioned are the detailed, sculpted model of a railroad mail car in Chicago's Rose Hill Cemetery for its developer and the beach ball-sized granite baseball in Grace-

S. P. Dinsmoor's mausoleum, "Garden of Eden," Lucas, Kansas

land Cemetery for the first president of the National League. J. Sterling Morton, the father of Arbor Day, is buried, fittingly enough, at the foot of an enormous carved limestone tree in Nebraska City's Wyuka Cemetery. In the Sierra Vista Cemetery of Taos, New Mexico, Jon Michael Passmore (1944–1975) speaks to us from an early grave and lays claim to a meteoric version of the life well lived:

> I would rather be ashes than dust. I would rather my spark should burn out in a brilliant blaze than it should be stifled in dry rot. I would rather be a superb meteor, every atom of me in magnificent glow, than a sleepy and permanent planet. Man's chief purpose is to live—not to exist. I shall not waste my days trying to prolong them. I shall use my time.

S. P. Dinsmoor, of Lucas, Kansas, constructed a cut stone "log" cabin and a wonderland of concrete sculpture tableaus based on his views of human behavior, socialism, and the Bible. The Goddess of Liberty, Cain and Abel, a giant concrete flag, Adam and Eve, the crucifixion of "labor," and many other allegorical scenes can be picked out among the birds, animals, and events that form a concrete web around the cabin. This outstanding folk art site, built between 1905 and 1930, is open to the public. By looking at Dinsmoor's work and reading his book, *The Cabin Home*, one comes to know him quite intimately. Those who want to know him even better can look at his badly deteriorated body in a glass-topped coffin inside the spectacular forty-foot stone mausoleum he built.

*The Cemetery and the Living* / 23

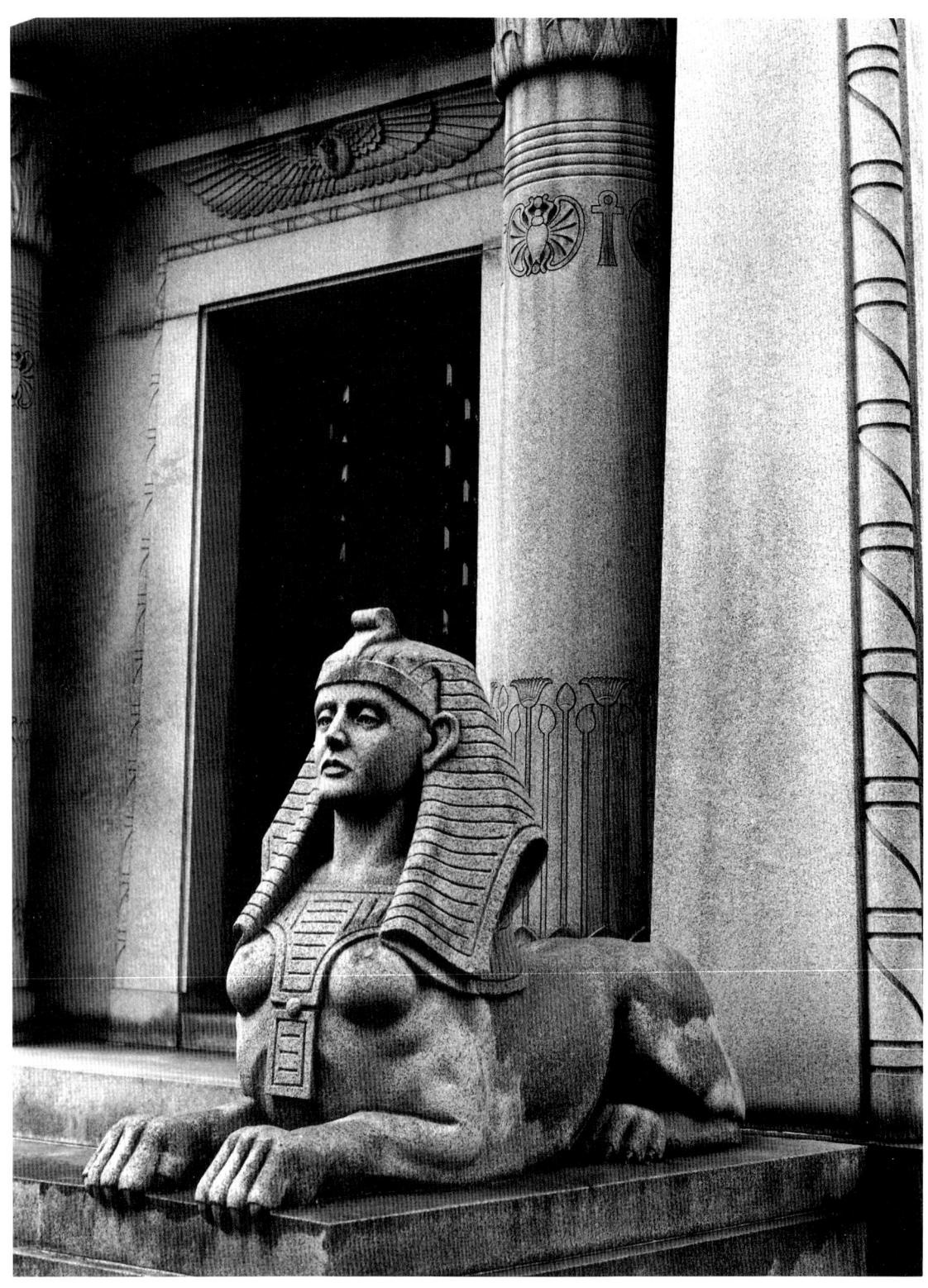

Egyptian mausoleum, Calvary Cemetery, St. Louis

24 / *Soul in the Stone*

The typical Heartland urban cemetery will contain examples of imagery from ancient cultures, romanticized and adapted to suit new purposes. Classical and Egyptian revival styles are common on mausoleum and gravestone detailing. One Egyptian mausoleum in Chicago's Graceland Cemetery even features a stained glass window that depicts a landscape at Giza, complete with pyramids and palm trees. Greek motifs have the additional appeal of an association with republican principles, but, because death equaled extinction to most of the pagan citizens of ancient Greece, the tranquil Doric edifices quietly contradict the beliefs of the mostly Christian nation that borrowed them. Gothic fragments and ruined abbeys, like those destroyed by King Henry VIII all over England, are also popular themes. Although the use of the Gothic style is not always stylistically pure in cemeteries, it at least represents a point of departure that is harmonious with the prevailing beliefs of the typical Heartland family.

Identification with pagan cultures confers on the departed a nobility by association that helps to dignify feelings that are difficult for survivors to express, but it also leaves both deceased and survivors in strange company. It would be rare indeed if any member of the family could describe the ancient pharaonic meaning of the symbols that appear on the Egyptian revival family tomb—the winged globe, the sphinx, the obelisk, the inverted lotus flowers, the scarab, or the serpent who is devouring his own tail. These symbols are meant for ambience only and their true significance would constitute the ultimate heresy for a typical Christian family in America's Heartland. Just to be safe, one St. Louis family affixed a Catholic Sacred Heart to the center of the Egyptian funerary wings that spread across the entablature of their mausoleum in Calvary Cemetery. This practice, which may use any of several Christian symbols, is not unusual, and it apparently neutralizes the polluting powers of the pagan imagery, without diluting the associations of immortality they carry.

Some borrowed and romanticized images can be quite localized. Southeast Nebraska has at least two "Wyuka" cemeteries—one in Lincoln and the other in Nebraska City. The word "Wyuka" is Sioux; it describes a "place of rest" for hunters or migratory peoples on long marches, although it was never meant to refer to a place of burial. In cemeteries, liberties are taken with other cultures' concepts, as well as architectural styles.

Other symbols that appear in Heartland cemeteries include the hourglass, sometimes winged, to remind us of the urgency of life; the butterfly, and the candle, symbols of the human soul; the owl as the messenger; the fern and the anchor, indicating hope; the lily for purity; and the rose for love. Angels are used in all Christian cemeteries, as emissaries between heaven and earth. Whether pointing toward heaven, guiding the deceased's soul upward, away from earthly bonds, or simply joining in the mourning, they provide us with a quasi-human personage who helps us make the transition into incomprehensible eternity. Shrouded urns, cannons, and spheres indicate the gift of rest. Similarly, discarded shoes, hats, and other articles of clothing symbolize the laying down of life's burdens.

Among Christians, the willow tree symbolizes the Christian faith, which, like the willow, can thrive anywhere on earth. It also implies sorrow with its shape and its popular nickname, weeping willow. The cross, surprisingly, was rarely used as a headstone by mainstream Protestants until well into the twentieth century. In the Heartland, a nineteenth-century cross almost always indicates a Catholic burial. Protestants were suspi-

Bellefontaine Cemetery, St. Louis

cious of, even hostile to, the use of the cross, because they associated it with the corruption and power of the Roman Catholic Church, and the passions of the Reformation burned brightly well into this century. In general, the cross refers to the crucifixion of Jesus and represents the salvation of the Christian faith. The circle, which is sometimes used behind the intersection of the vertical shaft and crossbar, as in the Celtic cross, symbolizes eternity, which has no beginning or end. The Russian Orthodox cross uses an extra diagonal post near the bottom of the shaft that represents the crucified Christ, lifting his foot in agony. The fish, a symbol for the Christian faith since the days of clandestine worship in Rome's catacombs, is rarely used on tombstones.

Early Protestant graves are likely to be marked by an open Bible, angels in many forms, clasped hands of fellowship, or by a single hand, its index finger pointing toward heaven, the ultimate destination of the deceased's soul. Taking things one step further, many tombstones feature the parting gates of heaven and occasionally the opulent mansions that await the faithful. The dove represents faith. The oak leaf, the acorn, and ivy all symbolize strength; the olive branch, peace. Harvested wheat, or other grain, represents the harvesting of the faithful. It is fun to simply fantasize about the meaning of the flowing pump that appeared on a tombstone in Mount Mora, or the star in Bellefontaine that hovered above the sea on the east side of the monument and sank into it on the west.

Among Catholics, the Sacred Heart of Jesus, surrounded by a crown of thorns, or the Sacred Heart of the Virgin, pierced by a sword, will appear with regularity. In the days of intense conflict between the mother church and breakaway Protestants, the concept of consecrated ground required an entirely separate site for Catholic burials, but in modern times the individual plot may be consecrated at the time of interment. Many Catholic tombstones take the form of wood, stone, or metal crosses, and the stone markers of Hispanic Colorado or New Mexico will often be illustrated with an image of a hand grasping a cross or a chalice. Images of the crucifixion or of the Blessed Virgin are used quite often, sometimes taking the form of little statues that sit in glass-covered niches cut into the tombstone, like small reliquaries. Snakes, the embodiment of evil, are sometimes shown being crushed beneath the feet of the Virgin. Rosaries are used as illustrations or occasionally hung on tombstones as accessories.

Jewish tombstones embody an interesting cultural and theological curiosity. The second commandment states unequivocally: "Thou shalt not make unto thee any graven image, or any likeness of anything that is in heaven above, or that is in the earth beneath, or that is in the water under the earth." This prohibition, shared by Muslims, has traditionally remained unenforced where the making of grave markers is concerned. The rich and beautiful imagery that one might see in the old Jewish Cemetery of Prague, or in the unattended graveyards of northeastern Romania, gives testament to the enthusiasm with which this exemption was embraced. While Jewish tombstones in the United States are traditionally plainer than those in the Old World, decorative examples can still be found, especially where immigration was early and heavy. Although the Heartland is popularly thought by those who live outside the area to contain only warring camps of Baptist and Methodist farmers, the truth is much more complex. Sizable Jewish communities have thrived all across the area, and when a new area was settled by Jews, the first order of business was to consecrate a cemetery. Rituals and rules governing the disposition of Jewish dead are more rigid than those of typical Christians. Conservative Jews allow only wood caskets to be used in burials and these caskets cannot contain nails or screws. "Kittle" coats, worn by Jews on only the most solemn occasions, such as marriage, high holidays, or burials, are the basis for the Masons' ritual aprons. The classic shroud, or burial shirt, can have no buttons and, as the grim old joke goes, no pockets.

Images to be found in Jewish cemeteries include the Lion of Judah Macabee, a great hero of Hebrew history who fought a guerrilla war against the Roman Empire and at last "restored the temple" of religious expression. Also used often are the tablets of the law, the moel hand, holding the knife of Biblical sacrifice or circumcision, and the

Union Cemetery, Milwaukee, Wisconsin

omnipresent six-pointed Star of David, which has religious and political significance, symbolizing the ancient state of Israel. Many Jewish stones are inscribed in Hebrew, although it is often mixed with English. The sign of "Kohayn," the dividing of the fingers symmetrically into twos, indicates the giving of the benediction by the traditional family of priests. The Levites, represented on the stone by a laver, or cup, have traditionally performed the ritual of pouring water onto the hands of the Kohayn before he gives the benediction.

Some Jewish iconography was improvised into cryptic forms in order to escape persecution. During the Spanish Inquisition many Jewish citizens joined the conquistadors disappearing into their ranks. A number of these escapees were tried, convicted, and burned in effigy in Spain as they made their way to the New World. Pretending conversion, or

Mt. Mora Cemetery, St. Joseph, Missouri

simply hiding their true identities, they lived in Mexico and eventually migrated to New Mexico, where they settled and stayed for generations as so-called hidden Jews. Rituals and worship were practiced in secret, and a compulsively cryptic society grew up around the layers of deception. In some families, children weren't told they were Jewish until they were grown. In many cases, only the tombstones betrayed the secret. In lieu of the Star of David, some markers featured a six-pointed rose blossom, as a shadowy declaration of the deceased's actual faith. Later, open migrations by Jewish settlers did not coax the secret Jews from their hiding places. Keeping the secret became a habitual way of life. Only in the latter part of the twentieth century have some hidden Jews come forward to publicly acknowledge their identity. Although it represents the later, openly Jewish group, a tombstone like the one for "Luis Gold" in Santa Fe's Fairview Cemetery still provokes double takes among those who have stereotypical views of New Mexico's demographics.

*The Cemetery and the Living* / 29

The institution of marriage is the source of much symbolism and expression in the typical Heartland cemetery, since its implications are both worldly and spiritual. Husband and wife will often share a common stone, set in place sometimes after the death of only one spouse and in some cases while both are still alive. This approach serves to indicate real commitment to their marriage and also satisfies the need of industrious middle Americans to take care of business sooner rather than later. Modern tombstones often supply the visitor with dates of marriage and an illustration of bells, hearts, or wedding rings. Older monuments can take the form of twin columns, trees, or truncated obelisks linked by a garland of flowers, or any inventive and passionate expressions that flow from one of life's more difficult losses. In the heyday of sculpted portraiture, twin busts in either low relief or in the round were not unusual. In Denver's Fairmount Cemetery, the likenesses of Frank and Bette Kaub face each other for eternity, under a classical roof and behind panels of glass. In Milwaukee's Union Cemetery, the full-length, life-sized effigies of Augusta and Carl Niss lie side by side, bringing to mind the statues of knights and clergymen that can be seen in Europe's Gothic churches. This elaborate approach is unusual in the United States, but the reference to marriage in some form is surely the most common in the Heartland cemetery.

The family plot, much like areas set aside for occupational groups, usually begins with a central monument around which smaller individual stones cluster. Older monuments sometimes encompass very large extended families and several generations, but this phenomenon has mostly disappeared with the advent of modern, mobile families who typically scatter to the four winds. Family plots were often fenced off with decorative wrought iron or carved stone. The family of John Kirschner of St. Joseph, Missouri, rests behind a complex iron demarcation that includes decorative lyres and angels. The tree trunk, sometimes erected by the Woodmen of the World organization, is a common motif when stone is used to indicate a family plot. Often the enclosure around the site will take the form of a sculpted "wooden" fence and the individual markers will be single logs. This metaphor contributes to a feeling of family unity and also makes reference to the harvesting of the faithful for the final blaze of judgment—as God's cord wood. The Harding family in Nebraska City's Wyuka Cemetery rests beneath a full-sized rolltop desk carved from marble. The desk is presented as open and, along with the ink well and other accessories, individual books are stacked and scattered across the surface of the desk, bearing the names of family members.

Along with the dispersal of the family, the move toward easy cemetery maintenance has contributed to the demise of the extended family plot. The new generation of cemeteries and "memorial parks" is first and foremost a business, and complex, open-ended family plots, which require individual attention, are now mostly considered a frill, for which the new system has made no allowance.

Images that surround the death of a child are among the most poignant, since that death represents a violation of the natural process and a diminished future. Symbolizing innocence, the lamb is the most frequently seen motif on a child's tombstone. Sometimes the animal will be shown lying at the foot of a willow tree. At times the child is represented as a budding plant or flower, and a heavenly hand is shown reaching down to pluck it for use in a celestial bouquet. Birds, especially dead birds lying on the ground below an

Bellefontaine Cemetery, St. Louis

empty nest, express the special sorrow that afflicted pioneer families with dreary frequency. Life-sized sculpted portraits are not unusual, and the scale emphasizes the child's vulnerability to capricious mortality. Photographic portraits also are used frequently. In some cases, frontier families had no pictures of the child and photographs taken after death were used on the stone or in the family album. The spilled flower pot implies dashed hope and a kind of impatient grief, but most of the time losses are counted with weary resignation. These inscriptions typify the prevailing sentiment: "Budded on earth, to bloom in heaven." "Safe in the arms of Jesus. Sin cannot harm you there."

Other images used to mark the grave of a dead child include discarded shoes or clothing; an empty bed or crib; portraits; surrogate mourners, usually shown as weeping or

*The Cemetery and the Living* / 31

harp-playing cherubs; a carriage or boat in the form of a swan being guided by a concerned angel; and, more recently, toys. Illustrations on modern tombstones can include a variety of highly personal images. One Colorado child's stone features a sandblasted image of the space shuttle. In Lamoni, Iowa, a photograph of a little girl looks out of the porcelain and up into the sky, while an inscription below says: "Gone to be an angel." A passionate monument for Luella Belle Winn, in the city cemetery of Eudora, Kansas, goes one step further and betrays a hint of peevishness, amidst the grief and resignation: "Too good for earth, God called her home."

## Epitaphs

> Many a tombstone inscription is a grave error.
> —Laurence Peter

Cynicism aside, epitaphs and inscriptions are another source of valuable information. While the sentiments inscribed on tombstones are often full of hyperbole and romantic flights of fancy, their complete meanings can often be understood by reading between the lines and understanding the difference between human aspirations and the human condition. In the eighteenth and nineteenth centuries, there were informal libraries of verse and prose statements available in clergy archives, in catalogues from monument makers, and in the cemeteries themselves. Probably the most common source of inscriptions was the Bible, from which relevant verses could be taken and juxtaposed with the spent life of a member of the flock, either because the deceased personified a given verse or because it represented the collective hopes and feelings of friends and family. The selection or composition of an epitaph gives the survivors an opportunity to vent their emotions, brandish their faith, and publicly lay claim to a special and permanent relationship with the departed.

Many, but not all, of the standard inscriptions were religious in nature, and even in that context there were choices; some emphasized peacefulness, some hope, some even expressed a degree of doubt about the ultimate disposition of the soul. Formal, possibly detached relationships produced dutiful sentiments and proper chapter and verse. Intensely loving relationships produced passionate outpourings and sometimes original compositions. The death of a child usually generated naked emotion, even abandon on the part of the parents. The loss of a young spouse or sibling was generally marked with palpable pain and anguish. The passing of an older person who had lived a good and productive life often generated sober and philosophical reflection. Within these generalizations lie ambiguous and exceptional epitaphs that express unlimited forms of grief. Epitaphs were and are important means to qualify and express the complicated feelings of the bereaved.

The English are probably the best-known and most prolific authors of cemetery inscriptions, especially the classic couplet that we associate with eighteenth-century Great Britain and America. The early epitaphs that were imported into this country with the settlers from the British Isles were, like the tombstones they appeared on, designed to provide stern instruction, not to comfort the bereaved, except to hold out the promise of

the afterlife. In eighteenth-century England or New England, the stone would be likely to be decorated by some sort of death's head, or grim reaper. In the nineteenth-century Heartland, the image on the gravestone had become more gentle. The bleak and unbending message below remained popular into the twentieth century, however, and was made more intimate and ominous by the use of the first-person conversational form to simulate a discourse between the deceased and the visitor. Brought intact from England, this verse was surely carved ten thousand times, from Indiana to Colorado:

> Remember me, as you pass by.
> As you are now, so once was I.
> As I am now, so you must be.
> Prepare for death and follow me.

Wilson, Kansas, was originally settled by Czech immigrants, and it still considers itself to be the Czech Capital of Kansas. The interesting local cemetery, at the south edge of town, is full of Suobodas, Honomichls, and Soukups. Many of the older tombstones are inscribed in Czech or in imperfect English. Here the same message is partially defanged by the awkward wording:

> Remember friend, as you pass by,
> For I was once as you are now.
> As I am now, you once shall be.
> Remember death and follow me.

Cora and Harry Hetzel, also of Wilson, Kansas, died as infants and their parents left a standard inscription that typifies the resignation of the faithful:

> Sleep on, sweet babes,
> Sleep out thy rest;
> God called you home,
> He thought it best.

Similarly, the widow of J. B. Gilliland, who died in 1885, acknowledges her grief, but does not question the ultimate, benign plan of the Almighty:

> Dearest husband, thou hast left us
> And thy loss we deeply feel
> But this God that has bereft us
> He can all our sorrows heal.

This inscription too finds hope in the pain of loss:

> Lone is the house and sad the hour
> Since thy sweet smile is gone.
> But oh! a brighter home than ours
> In heaven is now thine own.

Beneath the two lambs that mark the resting place of infant twins Charlie and Berty, the epitaph paints an evocative picture of spring's afterlife:

> Heaven is not far away!
> There like an Eden, blossoming in gladness,
> Bloom the fair flowers the earth too rudely priced.

A polished black granite memorial stone in Topeka, Kansas, is, by contrast, businesslike and almost curt in its grimly detailed description of the demise of two young sisters:

> Sarah Shull, January 8, 1880
> Cora Shull, September 2, 1883
> Both perished July 21, 1907, off the Pacific coast
> By the sinking of the ship "Columbia,"
> To a depth exceeding half a mile.
> They Rest From Their Labors.

A touch of puritanism adds a bizarre, doubtful, accusatory quality to the lament for David Gaillard, who died at the age of sixteen:

> His aged and disconsolate parents have caused this white marble to be placed over his grave, as an emblem of his youth, affection and (we trust) purity.

In Nebraska City, Henry O. Stevenson died in 1864 at the age of twenty-four. Between the tassels of the shroud that drapes over the marble stone, his young widow penned an inscription that betrays the blush of romantic love, as well as more dutiful sentiments:

> Henry dear, I see thee now,
> Thy smiling dark eyes each joyous thought revealing.
> The raven curls tossed from thy upturned brow.
> How radiantly beams the look of heaven.
> Thou art not parted from our hearts forever.
> The ties of love death hath no power to sever.

Also in Nebraska City, the worn tree trunk monument of Esther J. Pinny bears an amusing epitaph that is eloquent in its simple power to evoke the nature of pioneer life on the Great Plains in the 1880s: "She done what she could."

Another brief tribute, to Sarah Ann Mallard, of Lawrence, Kansas, honors a long life of giving:

> Sarah Ann Mallard, wife of Isaac Killworth, 1857–1930
> A loving mother, a true friend and ministering angel.

Ontario Cemetery, on a hillside at the west edge of Ames, Iowa, holds a number of nineteenth-century tablets which feature barely legible epitaphs, like this one to nineteen-year-old "Amanda," whose last name is not readable. The stone lies broken and flat on the ground and grass intrudes over its edge, its low-relief pot of flowers, and the verse:

> Not grief nor pain, nor anxious care,
> Invade thy bounds, no mortal woes
> Can reach the peaceful sleeper here,
> While angels watch the soft repose.

Nearby, the stone of Milton E. Canady still stands erect. Milton lived twenty-seven years, until December 1880. The free-form inscription, below the clasped hands of fellowship, reads:

> Amiable and beloved husband, farewell.
> Thy years were few but thy virtues many:
> They are recorded not on this perishing stone
> but on the book of life and in the hearts
> of thy afflicted friends.

Another worn and broken stone found in Ontario Cemetery memorializes Nancy Ellen, who died shortly after her first birthday. The condition of the stone and the poor spelling of the brief inscription add to the pathos: "We left her sleping."

An even briefer epitaph, for a little girl at Bellefontaine Cemetery in St. Louis, reads simply: "Poor Cecile."

Although frontier women often died before their husbands, either in childbirth or by being literally worked to death, society still insisted on pretending that they existed on a kind of pedestal, virtuous but naive creatures whose innocence was almost childlike. For women who lived with some degree of comfort, this image was all the more emphasized. The gravestone of Ottilie Stephan, wife of Henry Hiemenz, is one example of the idealistic memorial to the flower of American womanhood which, although politically incorrect, is nonetheless touching. The fifteen-foot tall granite monument features a graceful female figure in a cape. Behind the figure, an enormous, roughly hewn cross forms a backdrop for a pious expression. Just below the rose petals that the figure has dropped at her feet, the inscription reads:

> In memory of the noblest, dearest, gentlest and most unselfish of women,
> Ottilie Stephan, wife of Henry Hiemenz, Jr.
> The ornament and blessing of his life.

On the same hillside, Henry Studniczka remembers his young wife, Katie Lumelius, with similiar phrases and a recumbent, pensive statue, who rests one elbow on a granite fainting couch:

> Here rests in sweet repose—until day breaks—beloved by
> everyone that knew her, the noblest of them all,
> Katie Lumelius, 1852–1913, for thirty eight years
> the loyal wife, the inspiration, the guardian angel of
> Henry Studniczka.

As moving as these passionate phrases are, the inscription on the stone of Emily Westwood Lewis, also in Bellefontaine, seems to paint a more realistic and genuine portrait of an apparently remakable person:

> She was one who never knew fear or cowardice, and above all sought truth in her dealings with life and her fellow men. She met life with strength and gladness, joyous to serve, joyous to grasp and hold its richest gifts, but seeing beyond the limits of this outer vision, into the world where the ideal reigns supreme. And when at last life's sands had run, she passed on with eagerness, To other worlds, leaving this one the gladder for her presence.

In an unusual ensemble, sisters Leonora and Lulu Halsted chose identical arched tombstones and linked them with a curious message that reads across the tops of the stones: "Life is—I am. . . . Death only dies."

On the flat, unadorned tablet erected for Blanche M. Tibbals, a sentimental poem pays tribute to her, without the usual obligatory deference to heaven:

> We miss thee from our home, dear
> We miss thee from thy place.
> A shadow o'er our life is cast,
> We miss the sunshine of thy face.
>
> We miss thy kind and willing hand
> Thy fond and earnest care.
> Our home is dark without thee.
> We miss thee everywhere.

It was not uncommon for Heartland pioneers to write their own epitaphs, which appears to have been the case with William S. Crouch of Maple Hill, Kansas:

> Guide thou our feet, lest weak we stray
> To right or left of thine own way.
> Stretch forth thy hand, lest any fall
> And be O' Lord, our all in all.
>
> And when our brief day has passed,
> Abide with us until the last.
> Disperse the gloom, the weak heart cheer,
> Reveal thy love, rebuke our fear.
>                         W.S.C.

Very often, especially on newer gravestones, the epitaph is supplanted by a one-line phrase, the common cliché being "Rest in Peace." Some other traditional graveyard one-liners include:

Rest, sweet rest.

Sweet rest in heaven.

Gone, but not forgotten.

Simply to thy cross I cling.

In hope of eternal life.

I'll be somewhere, working for my lord.

Erected by his desolate widow. Thy will be done.

Not dead, but sleeping.

Gone home.

I know whom I have believed.

Waiting in a holy stillness, wrapt in sleep.

The memory of the just is blessed.

Peace in the valley.

A little child shall lead them.

Let the little children come unto me.

Among recent monuments the equivalant phrases can be quite unorthodox:

A free spirit.

A loving man.

High jumping in heaven.

Forever in the pines.

The man of the mountains.

World's greatest truck driver.

Have a good flight.

I'd rather be drag racing.

She was a gem [a gem cutter's wife].

He catered to local riff raff.

Hit hard but play fair.

# Ethnic Influences

Looking for ethnic or nationalistic influences in Heartland cemeteries is an interesting but tricky pastime. Depending on the traditions of given ethnic or immigrant communities and the wishes of individual families or persons, characteristic qualities brought from the old country are either maintained zealously, incorporated partially, or ignored entirely. It is possible to find small town cemeteries or ethnic enclaves in the large necropolis that look nearly identical to cemeteries in Germany, Greece, or Russia. At other times, ethnic groups may use mainstream American monuments and add a small detail that links them with the old imagery or rituals. Occasionally, immigrant groups, such as the Spanish, mixed with the indigenous people of North America and eventually invented entirely new artistic styles. Finally, many newly arrived Americans changed their names, learned English, and turned their backs on their heritage.

Some imagery that we see continuously in Heartland cemeteries is too broadly based to be considered ethnic. The Gothic style, for instance, is reflected everywhere, from the graceful spires and tall windows of the most elegant mausoleums and chapels to the pointed arch at the top of many tombstones. While different countries often put an individual stamp on the Gothic cathedral, it remained essentially borderless and by the time it was imported into the United States even small details were used interchangeably and generically. Egyptian Revival, Classical Revival, and rare instances of Turkish or Moorish Revival were also used haphazardly all over Europe long before these styles appeared in America. That renders those styles irrelevant, representing as they do borrowed concepts and decorative elements that have no direct link with the source. The sculpted figure lying atop an actual or simulated sarcophagus is seen often in Europe, but the practice did not cross the Atlantic and reappear in America in great numbers. In any case, this device too is borderless and not identified with any particular country.

Some of the earliest, most obvious, and most numerous influences in the American cemetery come from the British Isles. The flat, vertical tablet tombstone, often featuring a low-relief illustration near the top, the elaborately woven Celtic cross, and the tradition of the epitaph all came directly and essentially unaltered from England and Ireland. These elements were originally used in the dense churchyards of the northeast in the sixteenth, seventeenth and eighteenth centuries, then incorporated into the nineteenth-century Heartland cemeteries more or less intact. Horizontal stones that stretch across the grave from the headstone to an occasional footstone are common in southern England and all over France, so it is often difficult to tell the origin of this element, unless there are accompanying features that provide additional clues. Heartland cemeteries, like the English ones, are generally a blend of the existing landscape and human manipulation. In France and Belgium, cemeteries are often stripped of all plant life and the space between graves is filled with gravel. This would look startling in middle America, but it can be seen in places that were settled by large numbers of French-speaking immigrants, such as in the New Orleans area. Stone gravesite coverings in the New World are sometimes decorated with ivy leaves in low relief, as a sign of faith and strength, and these can be found on the American plains.

English and Irish influences have much in common, but there are important differences as well. Most important is the Catholic versus Protestant conflict, which manifests itself in a number of ways. Irish immigrants resented English colonialism and interference in Ireland, so the images that tout Irish identity display some degree of defensiveness and chauvinism. The partially demolished abbey is a theme used often in Irish and Catholic cemeteries, and it implicitly makes reference to the conflict between the Catholic Church and King Henry VIII, which resulted in the destruction of many of the abbeys of England.

The Celtic cross takes the form of a Latin cross decorated by intricate interior weaving and a ring at the intersection of the vertical shaft and the cross bar. The beauty and variety of the Celtic cross led to a later, more generic use that cut across ethnic boundaries. Latin inscriptions are more likely to be seen in "Irish" cemeteries than "English" ones. The use of Irish harps or shamrocks as decorative elements generally appears to have no dark or secret significance. The cross as a headstone, the image of the Virgin, the reliquary alcoves, and the use of external accessories are all rare or nonexistent in the nineteenth-century Protestant cemetery. Evaluation of these differences is sometimes difficult because the elements present in any given cemetery may represent Irish versus English dynamics in one situation and Catholic versus Protestant in another. In some circumstances the conflict was low grade or nonexistent. It is easy to see the differences in New World Irish and English cemeteries, but it is not always easy to describe those differences clearly. Many of the familiar images of Protestant Heartland cemeteries, such as the clasped hands of fellowship, the open book, the laurel wreath, the pointing finger, and the willow tree, come from England and Protestant Germany. The phrase *In hoc signo [vinces]*, which means "by this sign you conquer," is often seen at the top of Catholic crosses, as is the familiar I.N.R.I. abbreviation, which identifies Jesus as the king of the Jews. Protestants often avoided inscriptions or symbols that could be readily associated with old Papist imagery, as a way of avoiding the taint of what they considered to be corrupt practices and concepts. As the ecumenical movement gained strength during the twentieth century, conflict between the major churches softened and symbolic themes began to be used more interchangeably.

In Bavaria and other parts of Germany that remained Catholic in the wake of the Reformation, gravestones also kept their Catholic characteristics, including the almost universal use of the cross, often rendered in decorative wrought iron with painted surfaces and occasional beadwork on wire frames, like that still done in southern France. Munich and Salzburg are full of beautiful and sophisticated examples of metal crosses. These crosses made their way to America, and they are still seen in communities that strive to maintain the Old World imagery. The western Kansas towns of Catharine, Liebenthal, Victoria, and Hays were settled in part by German Catholics, many of whom came from Russia, where they had settled under the temporary sponsorship of Catherine the Great. After Catherine's death, the fortunes of German settlers declined under less sympathetic Russian rulers, and many immigrated to America.

Probably the best collection of these iron crosses is in the churchyard of St. Fidelis, on the north edge of Victoria. Most of the crosses are made like the originals, with spirals, curls, and twists of iron or steel that transform the basic Latin cross shape into a fanciful

structure, on which is usually attached a porcelain plaque, bearing the name and dates of the deceased. In some cases, however, the cross may be constructed of modern industrial pipe reminiscent of plumbing fittings or clothesline poles, giving the monument a blue-collar charm. The pipe is sometimes painted with high-gloss black or silver paint. In the midst of all the other Old World elegance, the plumbing pipe variations are charming and humorous. It is easy to imagine clothesline rope stretched between them, much as clothes are hung out to dry on cord stretched between Mamluk tombstones in Cairo's "City of the Dead."

Pipe Cross, St. Fidelis Cemetery, Victoria, Kansas

It is surprising to learn that one of the major reasons for choosing the beautiful iron crosses over a standard gravestone was the cost. A typical iron cross cost about twenty dollars in the early twentieth century, much less than a marble or granite stone, which had to be imported from the East. Some of the earliest crosses in this area were made of wood, but the harsh weather and strong winds of the Kansas prairies made wood monuments deteriorate quickly, so that medium was abandoned when families became more established and had more money at their disposal.

Many of the blacksmiths who created the iron crosses are still remembered by name, including John Knoll, a German who was born in Russia. Knoll was a strong and talented man, who not only did blacksmith work but also ran a meat market and a restaurant and pulled teeth for locals when no dentist was available. The iron cross that was put up for him after he died still stands in the cemetery at Victoria. Knoll's chief competition was a blacksmith named Alois Hauser. The two maintained a friendly rivalry for several decades, each trying to outdo the other in the latest monument. Both of them worked in the area through the early part of the twentieth century and died in the 1930s. Ironically, Hauser's grave is marked by a simple stone. Iron crosses in Liebenthal were made by John Herrmann and in Hays they were done by Peter Bellman and his son Joseph. Sadly, many of the lyrical iron crosses have been taken down and replaced by ordinary tombstones. An area monument dealer told a newspaper interviewer that he usually broke the crosses up and sold the metal as scrap.

Another interesting phenomenon can be found at St. Fidelis. The Dreiling family "gruft" is a small brick building that contains an altar for meditation and an underground crypt located under two locked iron doors that sit flush with the floor. The gruft is also an import from German communities in Russia and Germany. Another nearby gruft, that of the Brungardt family, contains an interior panel that displays pictures and information relating to the dead.

At Timkin, Kansas, a hilltop cemetery for immigrant Bohemian Czechs also contains a few iron crosses, though these are flatter and simpler than the German variety. This cemetery originally held many Catholic graves, but in the wake of a dispute with the Protestants, most of the Catholic dead were removed and reburied elsewhere. Czech "freethinkers" were pioneer supporters of cremation, and a wonderful collection of artifacts and keepsakes can be found along with the remains of early cremations at the columbarium at Chicago's Bohemian National Cemetery.

Hispanic cemeteries can be found all across the Heartland, but the most numerous and unique examples are located, not surprisingly, in New Mexico and Colorado, where Spanish settlements predate those of other European immigrants by as much as three hundred years. Many of the Spanish settlers moved north from Mexico, splitting off from the original "conquistadors," sometimes marrying Indians and retreating into insular communities. The Hispanic cemetery was not imported wholesale into the New World but reinvented by the people who lived there over a period of several centuries. It is a phenomenon under constant refinement.

The now ubiquitous "camposanto," or blessed field, was introduced after Spanish settlers had seen and emulated the tombstones of later arrivals to the area. In the early days, before the U.S. government had established firm control over the high desert country of

Wooden Cross, Taos, New Mexico

somewhat ambiguous, having vaguely Gothic, Celtic, and Coptic detailing that is pierced to let light pass through. The base of these crosses is generally very decorative and broader than the vertical shaft. The plaque, which displays information about the deceased, appears at the intersection of the shaft and the cross bar, and it is usually accompanied by a cast crucifix. These crosses are seen often in France, but they seem to occur in almost unlimited varieties all over the Catholic areas of Western Europe. In the Heartland they appear frequently in older cemeteries that served recent immigrants and then seem to disappear within a generation or two.

Other ethnic groups can be found in cemeteries adjoining large communities of immigrants who did not assimilate quickly. Chicago, for instance, has the largest Polish community outside of Warsaw, so it would make sense to look for Polish tombstones on Chicago's near west side. Latvian neighborhoods are also an important part of Chicago's ethnic tradition. Milwaukee, Wisconsin, has several European enclaves worth exploring. Lindsborg, Kansas, is a small community with strong Swedish ties. Oriental immigrants, confined mostly to the Atlantic and Pacific coasts until recently, are now putting down roots in America's Heartland. It will be interesting to see if these new citizens keep their traditional imagery alive—as they have in Seattle and Vancouver, Canada—or if they elect to blend in quickly and accept the prevailing generic American monument styles. One distinctively "Oriental" monument, found in Denver's Fairmont Cemetery, gives rise to hope that not all of the old imagery will be left behind.

African Americans were not willing immigrants and what little in the way of traditions that survived the nightmare journey was mostly given up in the course of living the life of the slave. Many African countries have fascinating and colorful burial rituals. It would be wonderful if American cemeteries were filled with evolving examples of funerary art from Senegal, the Ivory Coast, and Nigeria, but any possibility of this was lost in the dehumanizing process of slavery, which destroyed most family, culture, and memory of the ancestral home that had been left so suddenly. Towns settled by black Americans, like Nicodemus in western Kansas, that tried to re-establish a cohesive and self-sufficient post–Civil War community have mostly been abandoned in favor of the large American city. Vanished with those communities are almost all vestiges of a recognizable tradition in cemetery artifacts. The black church, and its unique ritual, have survived, but little in the local cemetery can be traced to an African American origin. Crudely inscribed concrete tombstones on a segregated hillside tell us of poverty and little else. Cemeteries are now mostly color-blind, but it is cold comfort to say that the flat, bronze plaques of black Americans are little different from those of the whites.

Although Jewish communities have flourished in the Heartland for generations, the imagery to be found in their cemeteries is relatively narrow when compared with the rich tradition of some Christian cultures. Although the prohibition against "graven images" was waived in the case of tombstones, an apparent collective nervousness about pushing the tolerance of God, or a reticence caused by past persecutions and constant minority status, has caused American Jews, for the most part, to abandon the passionate and beautiful images that can be found in Old World graveyards.

Perhaps the liveliest of all cemetery traditions is that of the Italians. It is certainly the most grandiose, not only in terms of artistic excellence but also in its quantitative ambition. Both in Italy itself and among immigrants to America there is a strong identification with the Catholic Church and all its imagery. The Italians rival the Spanish in their adherence to and celebration of the many rituals that keep the faithful constantly interacting with their faith. In addition, Italian families constitute almost a secondary religion, and the preoccupation with blood relations produces another level of passion to be manifested. Porcelain photographic vignettes are more often seen in Italian sections of Heartland cemeteries than anywhere else, and inscriptions on stones often include some genealogical information. Poems or prose statements appear quite often on Italian stones, in both

Concrete grave marker, Topeka, Kansas

Italy and the United States. After the peoples of the British Isles, the Italians are the most likely to include an epitaph of some kind on a monument. Most important, the Italians have an unbroken tradition of skillful sculptors whose handiwork enables the bereaved to speak eloquently about the intensity of love and the pain of loss. Secular sentiments are understood and articulated with the same competence as religious themes. In both the European and the American Heartland cemetery, the vast majority of truly professional sculpture is Italian in origin. What in many countries is a quaint, narrow folk tradition, for the Italians is a direct link with the Carrara quarries and the heritage of Michelangelo. Quasi-sexual images mixed with dramatic representations of mortality usually indicate an Italian family or an Italian sculptor.

The information and illustrations included in this book do not represent a systematic collection or analysis of ethnic artifacts in Heartland cemeteries. I hope that the analysis of the material that found its way into the collection will provide enough illumination to stimulate further investigation on the part of other cemetery enthusiasts. Obviously, a truly exhaustive study of ethnic influences in Heartland cemeteries would be an entire book by itself. The material contained in this book was chosen in a subjective and personal process that has no scientific rationale or art historical boundaries. I included what I considered to be the most extraordinary and entertaining examples of cemetery art.

## Does the Cemetery Have a Future?

For those who love the Heartland cemetery and have the opportunity to explore it, the time could hardly be better. Our wonderful cemeteries may be the last major historical frontier of our collective consciousness, the last undiscovered expression of a complex and creative society. We can still read the old verse and touch the lichen-covered limestone erected by our ancestors, or smile at the libertarian present as it tries to come to grips with the conundrum of mortality. Many generations have collaborated in fashioning for us an open-air art museum, a grassy history book, a silent sociological diorama that is free of charge, always available but hardly ever occupied . . . above ground anyway.

The cemetery seems a place removed from time where nature flourishes and the past mingles with the present, encouraging reflection and wisdom as it tunes out the frantic and dubious daily "achievements" of life at the end of the twentieth century. It is a place that can shelter lovers and thinkers, and its silence gives meaning to the sounds of life. Best of all, in an age of bewildering changes, it is a place that is always the same. Or is it?

At the end of the twentieth century, the cemetery as we have known it is dying. The increasing population, the need for land, and the wavering commitment to the maintenance of our cemeteries is threatening the ongoing process that would keep it alive. Vandalism, urban smoke, car exhaust, acid rain, and for that matter, ordinary rain are eating up many of the exceptional monuments that help make our cemeteries treasures. Some decay aids our understanding of the machinery of mortality. An occasional illegible epitaph provides texture to the experience of sitting thoughtfully in the midst of our mysterious dissolution, but the day when all the inscriptions are unreadable will be a sad one indeed. Although there is a new interest in personalizing gravestones, very little of the

present work will truly replace the rapidly disappearing efforts of the eighteenth and nineteenth centuries. The granite bookends will be with us almost as long as our plastic containers, but most of the best monuments, sculpted from marble, limestone, and sandstone, will be seriously degraded in another generation.

As nineteenth-century monuments crumble and new cemeteries begin to resemble military storage depots, how will we preserve some semblance of funerary contact with our pluralistic natures and individual voices? Will we begin to build more shelters for gravestones, spending precious resources to preserve monuments like stone mummies? Should we remove gravestones to museums, to prevent their theft or further deterioration? Gravestones have already been put up for sale at fashionable auction houses and then withdrawn amid howls of protest.

In May of 1993 I photographed a charming wooden cross in the El Prado, New Mexico, Campo Santo and, hoping to improve upon the first effort, returned to the cemetery in August of the same year. By that time the cross was gone—thrown away by caretakers or taken to the trendy foyer of some upscale Taos home. A trip to Maplewood Cemetery, in Emporia, Kansas, to find a sculpted portrait of the so-called little boy blue turned up only a Lord Fauntleroy shoe and a disembodied hand emerging from a cuff. Vandals had consigned the rest of the monument to oblivion.

There may be no way to save the American cemetery on a large scale, short of an unexpected reversal of historical trends. As friends and family desert the cemetery, the owner-operators of a new generation of burial grounds feel free to institute new, rigid rules prohibiting unusual or outsized monuments from being erected. This sad situation in turn perpetuates that cycle of events—or lack of events, as the case may be.

Cremation, once despised by organized religion as an impediment to resurrection, is now encouraged by many churches and romanticized by secular society. It certainly seems romantic compared to rows of identical ground-level plaques. The scattering of ashes over vegetable gardens or the Rocky Mountains makes new cemeteries seem increasingly irrelevant.

In the absence of an ongoing process that replaces the lost with the newly created, our attention shifts to the preservation of the finite remnants of the past. It may be necessary to remove the most remarkable monuments to some on-site shelter or put them in a museum like the tombstones of ancient Rome. Individual elements of Athens' Parthenon are being removed for storage in protected environments and replaced with cast facsimiles that are not so precious or so vulnerable to air pollution. This may be a viable solution in cases of extraordinary monuments that have broad public appeal, but ordinary gravestones seem truly doomed. We can keep some connection with our biological and spiritual past by encouraging and appreciating the more personal monuments that have begun to appear in the 1980s and 1990s. As with art and architecture, however, the skill to produce high-quality monuments has been mainly forgotten and the collective will which urged society toward romantic memorialization has been mostly lost.

Even in an age of spiritual doubt and the triumph of the utilitarian, human beings need some means to come to grips with their mortality and fit themselves into the scheme of existence. The exact form that this process will assume has not yet revealed itself. The

cemetery remains with us as one institution that enabled previous generations to cope with the ultimate mystery of life and death. Until we reinvent our spiritual impulses, it would seem wise to hold onto some of the old forms. If the monuments to us, or our parents, reveal nothing of value, it may still benefit the living to contemplate the gravestones of our great-grandparents.

As a practical matter, it seems clear that the treasures we still have must be at least photographed and saved in that way in publications or archives. Small improvements in security and educational efforts might help to cut down on vandalism. Cleaner air in the cities would benefit the living as well as the delicate marble tablets in the local cemetery. Most important to this generation of Heartland residents, however, is the expanded enjoyment and use of the historical cemetery while it is still available to all of us. The slow, inexorable loss of a piece of our tangible history may be a sad but inevitable occurrence in a universe where all things must pass. Let us all hope that the Heartland cemetery will not live out the rest of its days unnoticed and unappreciated by a generation that stands to learn much from its images.

# Religious Iconography

Not surprisingly, religious themes and motifs abound in the cemeteries of America's Heartland, but interpretation of these images is not as easy and straightforward as one might expect. In many European cultures, the hardy willow tree, able to grow nearly anywhere around the world, represented the gospel of Christ and its universal acceptance on every continent. In other cultures, among them that of the American frontier, the willow may be an expression of impotent weeping. It is difficult to know what the sculptor and family intended when they chose this image, but the epitaph in German is unambiguous:

> Christ is my life.
> To die is my gain.
> To him I have surrendered,
> And with joy I go to join him.

Elizabeth, wife of U. H. Backhaus, is resting here in peace and awaiting the day of judgment. Most of the tombstones at this small cemetery in Femme Osage, Missouri, are inscribed in German, and the messages reflect the industry and resignation of immigrants eager to please their God in heaven and do their duty on earth.

52 / *Soul in the Stone*

An open Bible hovers above the remains of Mary Judge, while a hand on her father's headstone points to heaven. Starting point for the journey is Oak Hill Cemetery, in Lawrence, Kansas. The two illustrations, rendered in low relief, are among the most common to be found in Protestant cemeteries.

William and Elinor Bush lie in Denver's Fairmount Cemetery, at the foot of the Rocky Mountains. Their children commissioned this spectacular marble monument, the top part of which appears to have been carved from one piece of stone. Sculpture of this quality was generally done in Italy, although some immigrant artisans did fine work in scattered locations around the United States. The anchor and chain represent hope, wrapped firmly around the cross. The inscription reflects a comforting preoccupation with the life to follow:

> Swift to its close ebbs out life's little day,
> Earth's joys grow dim, its glories pass away.
> Change and decay in all around I see
> O Thou who changest not, abide with me.

Religious Iconography / 53

54 / Soul in the Stone

The path is straight and narrow, but it leads to an unusually detailed depiction of the mansions that await the faithful in heaven. This image, in Aspen, Colorado, was done in low relief on black granite. It will last for generations, whereas many of the nearby softer marble monuments are melting away. Granite is more difficult to quarry than marble and was not widely used until the twentieth century. Its hardness also limited the imagery that most artisans could produce. Few could manage the popular Victorian in-the-round sculpture that was commonly done in marble, so most granite stones feature two-dimensional representations.

This serene mourner holds a garland of flowers and clings closely to the cross in Denver, Colorado. The inscription below bids the visitor also to be at peace:

> Weep not, my loved ones, over that mouldering clay
> But look up and ever outward, to my spirit, bright as day
> In life we were united in the earthly bonds of love
> We will be bound the same in spirit when we meet in heaven above.
> What to thee can be much sweeter than the thought that I am near
> That I stand ready to greet thee, as thou enter this bright sphere.

*Religious Iconography / 55*

In hope of eternal life

In Mount Mora Cemetery, in St. Joseph, Missouri, Bavarian-born John Kirschner and his family rest beneath the portentous angels and lyres in the iron fence. Before the turn of the century, use of the cross as a major motif in monuments usually indicated a Catholic family and was rare among Protestants, who associated the cross more with papal corruption than with the image of the crucifixion. Bavaria, in southern Germany, remained largely loyal to the Roman Catholic Church, whereas most of Germany followed the Reformation.

In Kansas City, Missouri's, Elmwood Cemetery, a spiritually rapt maiden holds to her anchor of hope and fixes her gaze on a place not of this world. She embodies the collective piety of the faithful as well as their inclination to leave their fate to the mercy of heaven: "In hope of eternal life."

Religious Iconography / 57

C. G. Barker is remembered with this marble headstone displaying a harvest motif, some of which is rendered ambiguous by the passage of time. The chilling and venerable verse is clear enough, however, and reminiscent of the no-nonsense monuments that were used in England and New England during an earlier time, when epitaphs were meant to instruct and improve the character of the living rather than comfort them:

> Remember friends, as you pass by,
> As you are now, so was I.
> As I am now, you will be,
> Prepare for death and follow me.

Hands of fellowship and of deliverance welcome W. K. McKissick of Nebraska City, Nebraska, and Mary Crawford of Denver, Colorado, into the heavenly fold.

Religious Iconography / 59

A Celtic cross, with its characteristic ring providing a backdrop for the intersection of the shaft and crossbar, stands over the Thacher family plot at Oak Hill Cemetery in Lawrence, Kansas. This cross is modestly decorated, but many Celtic crosses feature densely woven surfaces in low relief, bringing to mind the complex variations of Coptic crosses from Ethiopia and Egypt. At the base of the cross, the Greek letters chi and rho reproduce the inscription found on the earliest Christian artifacts. They allude to the first two letters of Christ's name and celebrate his advent as "the anointed one."

Life, Truth, and Love are sculpturally emphasized and celebrated by this namesake tombstone, erected by the three sons of Joseph Love in Denver's Fairmount Cemetery. The celestial gates are opening to reveal the kingdom of heaven and admit one of the faithful.

Religious Iconography / 61

A Jewish tombstone in a rural cemetery near Eudora, Kansas, displays the mixture of English and Hebrew common on Jewish monuments. The hands are shown making the sign for the Kohayn, the traditional priests of Israel, and they also represent the offering of the ritual benediction. Jewish tombstones tend to be more modest than those of the gentile community. Even though tombstones are exempted from the old prohibition against graven images, the spirit of the law is usually observed, with a minimum of ostentation. The dropping of pebbles at the foot of the stone, to indicate a visit by friends or family, is an Old World custom that is sometimes still practiced in America.

62 / *Soul in the Stone*

פ׳נ
הש״ץ המנגן גדול ר׳ ניסן בר
שניאור זלמן גאלדשטיין ז״ל
מת בשם טוב גדול ביום כ׳
אדר א׳ שנת תרפ׳ז
✡ תנצב״ה ✡

REV. NATHAN
GOLDSTEIN
1874 — 1927

Reverend Nathan Goldstein looks out from the Children of Israel Cemetery in Des Moines, Iowa, the only completely Jewish cemetery in the area. The top-hatted rabbi not only appears in the form of a porcelain photograph, he manages to look rather dapper in the process. The Star of David, which appears at the bottom of the Hebrew inscription, is the most common symbol used on Jewish tombstones, although pictorial representations of tribal identity are seen quite frequently.

The Children of Israel Cemetery contains about one hundred graves, but no burials have taken place there since 1945. The caretaker can be reached at the Beth El Jacob Synagogue, but the unannounced visitor to the cemetery should be prepared to scale a five-foot wall, as the gate is normally locked. There are also Jewish sections in the Glendale and Woodland Cemeteries of Des Moines.

# A Life Well Lived

While religious themes dominate the typical Heartland cemetery, sizable numbers of maverick monuments dwell on the life, philosophy, vocation, or peculiarities of the deceased. The afterlife is de-emphasized in favor of celebration of the finite but meaningful endeavors of ordinary and extraordinary people, offering a life well lived as an antidote to the bitter medicine of mortality. Grave markers in this category take forms that are as limitless as the accomplishments and fantasies of residents of the region.

In a small cemetery near Lincoln, Kansas, James S. Jacobs finally rests from his labors. He was the son of a local veterinarian and a traveling salesman by trade. The marble suitcase that serves as his tombstone brings to mind the countless screen doors that he presumably peered through as he attempted to interest the lady of the house in the contents of the omnipresent and heavy grip. Jacobs died of pulmonary disease, sometimes called "the grippe," which was common and only marginally treatable in 1891. Perhaps the use of a suitcase, or grip, as a motif is a play on words. The inscription, "Here is where he stoped last," does seem to imply that he worked until the very end.

The skillful artisan who fashioned this beautifully detailed monument apparently did not have a proofreader to tell him that "stopped" has two P's.

James Jacobs's mother and father, who reportedly did not believe in tombstones, are buried nearby in unmarked graves.

The Tulsa, Oklahoma, tombstone of Del and Alta Correll is in keeping with Del's vocation as a jeweler. The granite was cut and assembled in the shape of two faceted gems, nestled sideways into the base. The wedding rings celebrate their love, the badges indicate that they were gregarious joiners, and the inscriptions proclaim that they were free spirits.

*A Life Well Lived* / 65

66 / *Soul in the Stone*

Bedford, Indiana, was an important source of limestone and of the skilled craftsmen who worked its quarries and shops in large numbers until World War II. The area supplied all the limestone for New York's Empire State Building, as well as grave markers and architectural detailing for much of America's building boom in the first half of the twentieth century.

Louis J. Baker was an apprentice stone cutter in one of the local workshops, and he was well liked by his instructors and peers. After he was struck by lightning and killed on his way home from work, his co-workers fashioned a tombstone for him in the form of his workbench, or "banker," just as he had left it. The stone cornice Louis had been working on is depicted, partly covered by his work apron, along with his hammer, chisels, broom, and other items. In its detailing and conception, the bench itself is perhaps the most remarkable element of all. Warps and cracks and nails are reproduced faithfully, giving the whole ensemble an eerie intimacy.

*A Life Well Lived*

68 / *Soul in the Stone*

> I'd Rather Be Drag Racing!
>
> STEVEN R. JONES
> JAN. 21, 1952
> JULY 10, 1991
>
> WE WILL ALWAYS
> LOVE AND REMEMBER YOU

The photograph and message on this Tulsa tombstone leave no doubts as to how Steven R. Jones would like to spend eternity. Humor is often the best salve for the human condition and Steve's family obviously understands this well. The affixing of photographic images to porcelain, popular around the turn of the century, is becoming common once more, and casual poses have mostly replaced the stiff demeanor of the old Victorian portraits.

At Greenhill Cemetery in Bedford, Indiana, is a life-sized facsimile of Tom Barton, heading out for a round of golf. While most men are remembered for their work, Tom seems to prefer an eternity of leisure.

A Life Well Lived / 69

Anchors, aweigh! Granite vessels indicate a connection with Great Lakes shipping for these departed souls whose remains rest at Union Cemetery in Milwaukee, Wisconsin.

70 / *Soul in the Stone*

Wyuka Cemetery in Nebraska City, Nebraska, holds several extraordinary grave markers. This fifteen-foot stone tree watches over the remains of J. Sterling Morton, father of Arbor Day, and several other members of his family. The horizontal logs and other details of this family plot are skillfully carved from limestone. Dead and mutilated trees are a common symbol for death in cemeteries across the Heartland, but this example is particularly poignant, memorializing as it does a man who even in death is responsible for the planting and nurturing of trees all across the nation.

The "bark" of the tree is peeled back on all sides by the sculptor to reveal the names of many members of the Morton family. The ivy, symbol of strength, may represent the spirit of the deceased as it climbs and flourishes on the dead trunk. Near the base, a potted plant is spilled as a sign of grief.

*A Life Well Lived* / 71

72 / *Soul in the Stone*

St. Louis, Missouri, is an important shipping point for commerce along the Mississippi River, and Bellefontaine Cemetery contains several gravestones that celebrate men who piloted steamboats between St. Louis and New Orleans.

Best known of these riverboat captains was Isaiah Sellers (1802–1864), who plied the river for more than forty years. The tombstone shows Captain Sellers at the wheel of his riverboat. He is said to have been the first to use the pseudonym "Mark Twain," and after his death Samuel Clemens adopted the same nom de plume because it always stood for truthful writing, as he explains in *Life on the Mississippi*.

Less well-known pilots are buried beneath images of their glorious vessels. Time has softened the features of Captain Sellers.

A Life Well Lived / 73

Paul and Irene Unrein, happily, are still with us, but their colorized granite tombstone makes it clear that they already know how they want to be remembered. This Hays, Kansas, monument shares space with several of the beautiful iron crosses made by German immigrants in the early part of the twentieth century as well as many modern stones that use photographically based sandblasted images, including the one in the background.

Bill Stone was the operator of a restaurant and bar in Aspen, Colorado, where this stone was found. He was proud to serve the dispossessed working class of this mining town turned trendy ski resort, and the slogan that symbolized his place of business was used on his simple tombstone.

In the small Pomona, Kansas, cemetery, the untimely death of a high school student produced a wistful but hopeful memorial: "High Jumping in Heaven."

A Life Well Lived / 75

In Pomona, Kansas, a farmer shares eternity with his John Deere General Purpose tractor or his wife, or perhaps both.

76 / *Soul in the Stone*

Monica Mary Fitzpatrick of Aspen, Colorado, is remembered with a vaguely organic but abstract headstone and a mysterious little fetish made from a variety of materials.

*A Life Well Lived* / 77

Tonya Lynn and Coy Ray Wilkerson died together and are buried at Tulsa's Rose Hill Cemetery. The toy car or truck may hold the key to their sudden and mysterious exit from this world, but the love birds, balloons, flowers, and toy animals indicate a continuing celebration of their lives by loved ones.

In Oklahoma City, a woman known as "Scubalu" is shown doing what she apparently liked best. New sandblasting techniques make easy the reproduction of any linear, two-dimensional image on stone, encouraging the use of more personalized images after decades of look-alike monuments.

78 / *Soul in the Stone*

*A Life Well Lived / 79*

At Lincoln, Nebraska's, Wyuka Cemetery, Denis Monroe Mason and his truck "Red Dog Number Eleven" are remembered as a great team.

George S. Bangs was the railroad man who developed the mail car, and this accomplishment is commemorated in this complex and beautifully realized marker in Chicago's Rose Hill Cemetery. Bangs's epitaph, "His crowning effort—the fast mail," is carved into a decaying tree that forms part of the tableau.

80 / Soul in the Stone

*A Life Well Lived / 81*

The first commissioner of baseball's National League is immortalized at Graceland Cemetery in Chicago. Troy, Worcester, and Providence were big league teams when W. A. Hulbert was baseball's boss. The detailed granite baseball is considerably larger than the real thing, as can be seen by comparing it to the oak leaves in the foreground.

"Little Bob Figg" is memorialized as everybody's friend and as a baseball player or fan. This monument overlooks Lake Michigan, in Calvary Cemetery, which sits on the border between Chicago and Evanston, Illinois. This enormous Catholic cemetery is the final resting place for several Chicago mayors, three hundred priests, and eight hundred nuns.

*A Life Well Lived*

The Reverend I. E. Kenney of Des Moines, Iowa, is remembered for his persuasive sermons. His tombstone, in historic Woodland Cemetery, takes the form of a life-sized pulpit with a Bible atop it.

Chadwick G. Howard was in the process of restoring a WACO biplane when he passed away, so his family sent the image of his beloved fantasy with him, along with a phrase that he often used to bid others farewell. This stone sits in a rural cemetery near Hiawatha, Kansas.

*A Life Well Lived*

The Davis Memorial, which can be found in a small cemetery just east of Hiawatha, Kansas, is a truly remarkable piece of work; a monument to mankind's sentiment and compulsiveness, as well as to the lives of John and Sarah Davis.

John M. Davis commissioned the work in 1932, and the memorial was complete by 1940. Most of the sculptures were done in Carrara, Italy, by professional artists, and the beautifully detailed portraits are faithful likenesses. Mr. Davis would never tell how much the entire project cost, but it has been estimated to have set him back almost half a million dollars—quite a sum at the end of the Great Depression—nearly all of his family fortune. This

excess caused local grumbling about the squandering of resources in the midst of such hard times, but apparently a family feud is at least partially responsible for Davis's decision to spend the money.

When John Davis began to court Sarah, he was working for her father. Her family did not approve of the proposed union, thinking that she could do better than to marry one of the employees. The enmity between Davis and his wife's family lasted throughout their marriage, during which time he amassed a respectable fortune from his own farming efforts. It is said that Davis, whose marriage had produced no children, spent all his money on a memorial so that Sarah's family could not inherit it after his death.

The sequence begins on the west side, where

*A Life Well Lived* / 89

John and Sarah sit a respectable distance from each other in a love seat, presumably during their courtship. Sarah is next depicted as a young wife and then as a middle-aged matron, under the protective granite roof along the south side of the monument. Under the roof on the north side, Davis is shown before and after he lost a hand in a farming accident. The couple is then seen sitting together in identical arm chairs, comfortable in old age and sweet companionship, out in the weather on the south edge of the complex. Upon Sarah's death, Davis, in mourning, had himself sculpted alongside an equally sorrowful angel. The final stage of the memorial is represented in "Rock of Ages" granite

90 / *Soul in the Stone*

and shows Davis sitting alone, beside "The Vacant Chair."

Although it was built during the 1930s, the Davis Memorial reflects the Victorian habit of prolonged mourning. In addition to keeping alive the memory of these strange and interesting people, it provides us with a materialized glimpse into the sensibilities of human beings from another age, acting as a mirror for our shared feelings. Part of our collective history, the Davis Memorial has recently been vandalized and one of the portraits of John Davis has been decapitated. These photographs provide a record of the memorial before the damage was done.

*A Life Well Lived* / 91

92 / *Soul in the Stone*

*A Life Well Lived / 93*

94 / *Soul in the Stone*

# Secular Images: Familiar and Obscure

As in religious iconography, secular motifs may reflect images that are mostly forms of fashion or they may be carefully chosen individual expressions. Fashionable and familiar concepts are made extraordinary when rendered beautifully or strangely. Images such as blooming flowers, setting suns, and changing seasons serve to emphasize and romanticize the natural processes, giving a sense of belonging and ongoing participation to people who might otherwise feel overwhelmed by the celestial machinery of the universe.

Sculptors frequently use surrogate mourners, usually sorrowful cherubs or maidens, with or without angel wings, to express the collective grief of friends and family. This device lionizes the deceased by making the grief seem universal and implies interaction between heaven and earth that helps vent feelings of loss without engaging in self-indulgent personal displays. Sometimes animals, almost always dogs, are shown as mourners, crying anthropomorphic tears and wearing badges of disconsolate tribute.

This couple, shown in deathlike repose, appears to have been sculpted as portraiture, but the effect is generic and philosophically inert. Deathbed effigies such as these are rare in the United States but common in Western Europe, where representations can range from the romantic sentimentality of Romeo and Juliet figures, whose limbs are gracefully entwined in death, to dutifully proper configurations in which the couples seem unaware of each other and lie on their backs in an attitude of prayer, concerned only with their relationship with heaven. Occasionally, as in the effigies at St. Denis, in Paris, they can be brutally realistic, depicting the deceased as a gaunt or even decomposing corpse. This more gently rendered example, done for Augusta and Carl Niss, was erected in 1905 and can be found in Milwaukee, Wisconsin's, Union Cemetery.

We use the images of pharaonic religion of ancient Egypt as secular and generic symbols for mortality and the striving for immortality. All but the Egyptologist may have forgotten the literal meaning of the scarab or the serpent devouring its own tail, but they can still be seen on the Egyptian Revival mausoleums that sprang up in large numbers before and after the turn of the century.

This mausoleum, in the form of a pyramid, features two sculpted sentries who typify the eclectic abandon of necropolis architecture. The Egyptian sphinx guards the entrance while an angel looks plaintively toward an ambiguous heaven. The unlikely combination dilutes and nearly neutralizes the angel's theological identity. At times, Gothic spires can mix with pharaonic and even Art Deco details. This ensemble is one of many Egyptian Revival flights of fancy in Chicago's Graceland Cemetery.

96 / *Soul in the Stone*

Secular Images / 97

At Graceland Cemetery, Chicago, this mausoleum is more purely pharaonic, with its serpents, vultures, lotus blossoms, and pictorial stained glass depicting the pyramids at Giza, framed by Egyptian palm trees.

98 / *Soul in the Stone*

This tomb at Mount Mora Cemetery in St. Joseph, Missouri, adds columns much like those of Luxor's Karnak Temple. Lotus blossoms decorate the bronze doors along with a pull in the form of serpents and a scarab beetle, an Egyptian funerary symbol.

*Secular Images* / 99

In Denver's Fairmount Cemetery, Egyptian maidens, their garments decorated with hieroglyphics, guard the Celtic doors that lead into a minimalist mausoleum.

100 / *Soul in the Stone*

Secular Images / 101

In his *Devil's Dictionary*, writer Ambrose Bierce defines "mausoleum" as "the final and funniest folly of the rich." The Tate tomb, built in 1907, in Bellefontaine Cemetery, St. Louis, Missouri, seems to fit this definition.

Frank Tate, builder of this curious Egyptian Revival mausoleum, controlled most of the theater property in St. Louis at the turn of the century, as well as other real estate in New York and Chicago. Poor, working-class people have traditionally been fond of a particular dark joke, in which they rejoice in the death that finally makes them property owners. This mausoleum is now Frank Tate's only property.

A buxom sphinx adorns an Egyptian tomb in St. Louis's Calvary Cemetery.

*Secular Images* / *103*

William and Margaret James of Denver, Colorado, rest beneath a quasi-obelisk that looks by turns Celtic, Moorish, and Coptic. The pictorial flower motif continues onto another nearby monument for other members of the James family, seemingly in the form of a bird bath.

Secular Images / 105

A pouty cherub mopes above the grave of infant Emma Himmer, who rests in Greenhill Cemetery at Bedford, Indiana. The dispirited look on the face of this little angel seems to say more about human disappointment than it does about heaven's ultimate promise.

The inverted torch is a common symbol for death. This one, which looks a bit like a mop, is at Bellefontaine Cemetery, St. Louis.

Secular Images / 109

A surrogate mourner at Bellefontaine Cemetery, St. Louis, cradles a flower and looks into the sky with ritual grief that comes across as something closer to ennui.

110 / *Soul in the Stone*

A St. Louis surrogate mourner stands on a sphere and acknowledges the heavens. She has chosen to do her mourning in a very revealing costume, which gives the sculptor a chance to parade his skills and introduce some thinly veiled sensuousness into the bleak landscape of death. This monument was probably imported from Italy, where death is often given an erotic subtext.

Secular Images / 111

The Adolph J. Zang family plot is in Denver's Fairmount Cemetery. A reverent mourner bows her head toward the serpentine coils of smoke rising from an oil lamp, delicately rendered in low relief. The drooping shadow accentuates the Art Nouveau design of this turn-of-the-century monument.

The elaborate Wight Memorial, also in Denver, is a massive, mixed-media extravaganza of limestone, marble, and bronze. The dignified mourner here has sprouted wings, but the emphasis is still on an opulence and artfulness that have a decidedly worldly effect. Frederick Wight was at one time the director of Fairmount Cemetery, Colorado's second oldest major cemetery and repository for many of the area's most extraordinary pioneers.

A narrow shaft of light illuminates a sad but winsome vigil in Leadville, Colorado. Although the cross is used as a backdrop, the overall effect of this tableau is both morose and sensual. The maiden's bare shoulder only adds fuel to the fire of her lament.

114 / *Soul in the Stone*

Carrie Coleman's tombstone in St. Joseph, Missouri, uses the tree stump metaphor for death, made more palpable by the addition of fungi near the base of the trunk. As usual, the "bark" of the tree is peeled so that the vital information on the deceased can be inscribed, along with a now unreadable epitaph.

In Nebraska City's Wyuka Cemetery, the tree stump motif is turned into a planter.

Two accessory chairs, near grave sites at Bellefontaine Cemetery, St. Louis, offer the living a chance to rest in peace. The limestone chair is covered with lichen and has lost much of its original crispness,...

*Secular Images*

. . . but the curious metal chair has weathered well.

This overstuffed limestone arm chair sits at the Helms family plot in the White Chapel Memorial Gardens of Wichita, Kansas.

W. E. Hill's twelve-foot limestone monument in Nebraska City is given further drama with the addition of an hourglass, topped by an acorn shell and enclosed by a wooden frame. The hourglass serves to remind the living of the urgency with which they should pursue righteousness. Sometimes wings are added to the hourglass, to give it an even more insistent quality. In Europe, this symbol is often used with a scythe and a death's head, in case the onlooker is slow to get the point.

The Harding family plot at Wyuka Cemetery is surrounded by a low stone fence carved to resemble logs, but the central feature is a full-sized marble rolltop desk, the surface of which is covered with office supplies, an inkwell, and books, many of which are labeled with individual names. N. C. Harding, a Nebraska City pioneer and insurance salesman, designed his own tombstone together with J. Sterling Morton, the father of Arbor Day, who did the same. The two had become acquainted on a boat while Harding was moving from St. Louis. Harding sold the first insurance policy issued in the state of Nebraska. He was buried beneath the desk, a replica of the one in his insurance office, on March 30, 1915. The J. Sterling Morton monument, an enormous stone tree, is located nearby.

This bookish monument is at Oak Hill Cemetery, Lawrence, Kansas.

122 / *Soul in the Stone*

At a roadside cemetery near Truchas, New Mexico, Martin Brito and other family members are buried beneath this curious monument, the work of a local man who wielded a cutting torch and welding rod with artistic abandon. The featuring of the V-Twin motorcycles suggests that Martin died riding his beloved chopper, but the truth is much stranger. According to the locals, Martin often led children and groups of his peers on hikes in the nearby mountains. He was a bit of a clown, and on one trek he went to the edge of a high overlook and pretended to lose his balance for the entertainment of the rest of the hikers. His loss of balance became genuine and he fell to his death at the age of twenty-six.

This impressive limestone ensemble was carved in Bedford, Indiana, and erected at the Greenhill Cemetery.

John H. Strong of Aspen, Colorado, is remembered by this massive piece of petrified wood.

At Union Cemetery, in Milwaukee, Wisconsin, beautifully detailed trees, broken and mutilated, speak eloquently of painful loss. Signs of hope, such as the anchor, and indications of family and fraternal fellowship cushion the blows of mortality.

126 / *Soul in the Stone*

Secular Images / 127

In Kansas City's Elmwood Cemetery a weeping palm tree shelters an obelisk that overlooks the graves of Marie Antoinette (née Thoms), wife of F. Maehl, and other family members.

On February 23, 1925, Corel Sherwood, a friend of Charles Lindbergh, took off on a fatal flight that ended near Lincoln, Nebraska. One of many fatalities in the postwar development of commercial aviation, Corel was buried at Wyuka Cemetery in Lincoln, and half of his prop was used as a tombstone.

N. Grigsby, who was married to Abraham Lincoln's oldest sister, died in Attica, Kansas, on April 16, 1890. He was buried in the small cemetery near the town. Apparently Grigsby was a man who enjoyed having the last word. He instructed friends and family to erect, upon his death, an obelisk-shaped tombstone with an inscription:

> Through this inscription I wish to enter my dying protest against what is called The Democratic Party. I have watched it closely since the days of Jackson, and know that all the misfortunes of our Nation have come to it through this so-called party. Therefore, beware of this party of treason.

Secular Images / 129

Valley View Cemetery, in Garden City, Kansas, holds what must be one of the strangest tombstones in the United States. Mitchal Runnels, who was one of Garden City's earliest traffic fatalities, rests beneath the four-cylinder motor of his 1924 Chevrolet.

Mitchal's family moved from Colorado to Garden City in the mid-1920s. His father, who was wanted by the Colorado police, lived under an assumed name but the family thrived after their fresh start in Western Kansas. Mitchell loved automobiles and put money aside while he worked at various jobs in the Garden City area. Cars were unusual in that part of Kansas at the time, but he managed to find a second-hand Chevrolet and taught himself to fix and tune the engine. The Chevy was the light of his life.

At dusk on February 16, 1927, Mitchal left Kemper Auto Service and started home after a day of tinkering with the Chevy. At a Garden City rail crossing he was struck by the Santa Fe Chief and died shortly after being pulled from the wreckage. The Chevy was completely demolished, except for the engine, and it sat alongside the tracks for several days, drawing crowds of curious onlookers. Mitchal's father decided to use the engine for his son's tombstone. He put it atop a concrete slab and gave it a coat of silver paint before putting the name plate over the top, level with the valve springs.

Shortly after burying their son, the Runnels family left Garden City. Elm and cottonwood trees flourished in the cemetery, and after a couple of decades, one tree grew around the monument and swallowed it. Most of the locals forgot that it ever existed.

In 1967, the area was hit by a devastating tornado. The twister uprooted and split the tree that had obscured the tombstone. The Chevy engine was reborn and the old-timers began to talk again about the curious and poignant case of Mitchal Runnels.

During the 1880s, a Mr. and Mrs. Vanderlinde were passing through St. Joseph, Missouri, on their way to the promised land of the American West. Mrs. Vanderlinde died in childbirth while they were in St. Joseph. Her husband had her body embalmed and built a small brick crypt in St. Joseph's Mount Mora Cemetery. It is a modest tomb but remarkable for a project that had to be completed quickly, without any warning or preparation, by a man who had no home or friends in the area. It is free of ornament or comment, except for the name above the door, but the brick work shows the care taken by a loving hand. Shortly after the completion of the building, Mr. Vanderlinde moved on. The onlooker hopes he completed his journey.

Caretakers at the cemetery recently noticed that the wooden door had deteriorated beyond repair, so they removed it, after a quick look inside, and bricked up the entrance. Lying inside upon a plank atop two sawhorses was Maud Vanderlinde's still-preserved body, dressed in her wedding gown.

At Chicago's Rose Hill Cemetery a granite knight by sculptor Lorado Taft proclaims the ultimate victory for deceased newspaper magnate Victor Lawson, father of the *Chicago Daily News*. This monument is remarkable because only the best and most patient sculptors could manage to execute successfully an in-the-round statue from such hard stone.

*Secular Images* / 133

This Chicago monument seems to depict death himself.

134 / *Soul in the Stone*

This larger-than-life wolfhound is eternally vigilant in Denver, Colorado.

Secular Images / 135

A cryptic boulder is a common but mysterious point of departure in cemeteries all across the Heartland. This one, labeled with the family name, can be found at Highland Cemetery, in Wichita, Kansas, Wichita's oldest major cemetery. Founded in 1872, Highland is popularly known as "the resting place of the pioneers."

The gravestone for Jane Bicket Brock is in the form of a marble bench. While exploring a Wichita, Kansas, cemetery, I met by chance the craftsman who had inscribed the odd message on this monument. He could not explain the curious choice of words, but he did say that he had asked the thoroughly articulate clients several times if they were sure this was exactly what they wanted and they assured him it was.

*Secular Images*

The San Juan Nepomoceno Cemetery, founded in 1900, sits along the highway between Chilili and Mountain Air, New Mexico, in a clearing surrounded by piñon trees and other desert plants. Much of the cemetery contains traditional Hispanic funerary items, including the familiar painted wooden crosses, and concrete monuments that utilize glass or ceramic inlay. The colors of the plastic flowers fade quickly in the thin, high desert air, but the Astroturf that covers a few of the plots stays as green as winter wheat. In many ways this is a typical Hispanic, Catholic cemetery—full of pathos and passion and images of the Virgin.

Alongside these familiar images, however, are the unusual monuments marked "made by Horace McAfee," a name that seems out of place in the Manzano Mountains. During his career as a monument maker, Horace used a strange assortment of angle iron, sheet metal, highway department sign posts, household fixtures, and mysterious, decorative baubles that would look at home in a 1950s Buick parts catalogue. He bolted, welded, and otherwise assembled these items into grave markers for family members and other area residents, using poured concrete to create pads for plaques and reliquaries. The monuments are at once charming and repelling, resembling traps, cages, or inverted metal beds that are decorated with everyday objects and inexplicable junk. One example, built for Maria Pohl, uses a bowling ball set into a concrete pad as a central feature, and it sits next to a small metal cross that floats in a sea of ceramic fragments and is inscribed "known only to God."

Horace McAfee's great-grandfather arrived in Chilili, a small settlement in New Mexico's central mountains, in the middle of the nineteenth century. Robert McAfee, an Irish immigrant, originally from New York, came west with General Stephen Kearny, who had been sent to claim New Mexico territory for the United States government. Shortly

after homesteading in Antelope Springs and then moving to Chilili, Robert fell in love with and married a Hispanic woman named Perfecta Trujillo. Their family spoke with Spanish accents but many had green eyes.

Horace McAfee's father, Harry, gave up a portion of his young adulthood to fight in World War I, just as Horace did in World War II. Harry survived the trenches, but he and the rest of the family suffered from the great wave of diseases that appeared in central New Mexico during the 1930s. In 1933, only a month after Harry died of typhoid, his infant son Lory succumbed to diphtheria, as did daughter Lucy, who was two years old. Harry's sister Lena also perished that year, along with their father, George McAfee. All the dead were buried at Nepomoceno cemetery, and their graves were marked in the traditional ways, mostly with wooden crosses. Horace, twelve years old, was spared by the epidemic.

When Horace McAfee returned from World War II, he was appalled by the deterioration of the monuments, especially his father's. Horace had hoped his father would be admired and remembered for many generations. After deciding that he couldn't make a decent living in Chilili, Horace moved to nearby Albuquerque, married, and raised a family. While in Australia during the war, Horace had been impressed by a handmade metal grave monument and, after poking around a junkyard near his Albuquerque home, decided to make something similar for his father. It wasn't long before he was doing the same thing for all the McAfees who were buried in the Chilili cemetery as well as fashioning commissions for other locals who admired his work. His young son reportedly helped with some of the construction.

Horace bought scrap metal and car parts, door knobs, drawer pulls, and towel bars to assemble into curious ensembles that were eventually sprayed with aluminum paint. The decorative elements were accompanied by plaques that spell out Biblical phrases or philosophical messages. Even locals who wanted to keep their traditional Hispanic monuments were inspired by the work that was going on at Nepomoceno. Grave plots were renovated, fences were put around plots and grave markers were righted. Long after the last of the Horace McAfee memorials was erected, the cemetery south of Chilili remains a place of creativity and pride.

The most interesting of these steel monuments is still the complex built over the grave of Harry McAfee, Horace's father. Within the framework of angle iron and concrete-filled steel posts, a variety of weird details pull the eye one way and then the other. Above the standard marble military tombstone, which is almost lost in the clutter, there is a small reliquary with bars that features two painted busts of an ambiguous nature. To the left of them a tattered American flag flutters in the breeze, and another reliquary, which faces to the north side, contains a glass-covered photograph of the deceased as a young man in uniform. Toward the front, a doughboy helmet is bolted to a pair of metal straps and labeled "his army helmet." The straps are accented by some of the odd artifacts. On a concrete pad at ground level there is a hardware store eagle with spread wings, and a tooled metal plaque says "Visitors welcome, photos allowed." A vertical metal post rises above the rest of the monument and supports a sign that says "At rest, in peace." The top of the post becomes a makeshift cross, the arms of which look to be made from a Jeep bumper.

All around the cemetery, Horace has left his mark. The infant children of the family are buried beneath similar metal complexes and described as "God's Babies." At the entrance, the visitor is welcomed but also instructed as to appropriate behavior and provided with relevant scripture, most of which is punched patiently into sheet-metal plaques with an ice pick and a hammer. Vandals are warned away at the pedestrian gate with the inscription "vandals will face court action," and the wide swinging gates are labeled "Funerals only, Grave diggers gate—lock after digging grave."

During a 1984 newspaper interview, Horace McAfee expressed satisfaction and pride that his unusual monuments were widely admired and that they had ensured that his family would be be visited often, sometimes by perfect strangers. When he dies, however, Horace McAfee will, by choice, be buried beneath a simple white cross in Santa Fe's National Military Cemetery.

140 / *Soul in the Stone*

This version of Rodin's "The Thinker" was sculpted by Louis Paul Jonas in Hudson, New York. A surrogate thinker for Carl Norgren, this bronze ponders the ultimate question in Denver's Fairmount Cemetery.

Secular Images / 141

While on a tour of Italy in the early 1900s, Herman Luyties, owner of the first proprietary drug store in the city of St. Louis, Missouri, met and fell in love with a sculptor's model. Luyties proposed marriage to the beautiful lady, but she declined his offer and he returned to St. Louis brokenhearted. Before leaving Italy, he commissioned the sculptor to produce a twelve-foot marble statue based on his beloved model. After the statue was delivered to St. Louis, he kept it in the foyer of his home, so that he could see it every time he arrived or departed. Because the several-ton sculpture was thought to be damaging the structural integrity of the house, it was eventually moved to the family burial plot in Bellefontaine

Cemetery. After Luyties died at the age of fifty, he was buried at the foot of what came to be known as "the girl in the shadow box."

Herman Luyties was probably unaware that the statue produced for him was based on a cemetery monument that his love had modeled for previously.

I found and photographed this voluptuous angel in Viterbo, Italy, long before discovering the Luyties monument. The addition of wings makes her seductiveness all the more unsettling, bringing to mind a Mae West voice that coaxes us to "come on up to heaven and see me sometime."

*Secular Images* / 143

The transformation of chaos into order is suggested by this Topeka, Kansas, tombstone. The collective blessings of civilization are sometimes lionized as a humanist substitute for religious faith in secular monuments.

Gerard Andersen of Aspen, Colorado, is apparently portrayed here as he lectures a pair of rapt Boy Scouts. This memorial is welded cast iron.

The city cemetery at Eudora, Kansas, holds the Darling family plot. The Gothic fragment, bringing to mind the sacked abbeys of rural England, is a fairly common motif in mid-America. This example, however, is interestingly detailed and especially well realized. The upper right edge of the arch is decorated with a stone imitation of the mud nurseries left in barns by industrious wasps. Other signs of neglect and decay abound across the facade, punctuated by a pile of fallen brick below the window. The hourglass hovers above and—just in case we missed the point—Sarah Darling tells us to "prepare to follow me."

*Secular Images* / 145

This flight of fancy comes from Aspen, Colorado.

The fish is a commonly used Christian symbol, but this enormous tombstone, in Denver's Fairmount Cemetery, was fashioned for George W. Pell, a man for whom fish meant business. His son explained the monument to a newspaper interviewer in 1911: "You see, as far back as I can remember, the Pells have been in the fish business. Many of our relatives are in the business right now. I am in the fish business also, and when my son grows up he shall follow me in it. My father's name was George Washington Pell, my name is the same and so is that of my son, and if he ever grows up to be the father of a boy, that boy's name shall be George Washington Pell also." No information could be found to indicate whether or not the compulsive Pells managed to saddle the fourth generation with the identical name and vocation.

Italian sculptor Signor Garibaldi was brought by the family to Denver, and he completed the monument before returning home. The three fish pictured in the relief carving represent the three varieties that the Pell empire marketed most successfully, but the species are not identified anywhere on the stone. There is an inscription, on a separate marker, which reads: "George W. Pell, 1851–1911, a diamond in the rough."

Secular Images / 147

Leonora and Lulu Margaret Halsted rest side by side in St. Louis's Bellefontaine Cemetery. Their stones are decorated with contrasting flowers, but they are united by a pair of phrases that read across the top: "Life is—I am. Death only dies."

148 / *Soul in the Stone*

The resting place of Israel Swan, George Noon, Frank Miller, James Humphreys, and Wilson Bell was for over a hundred years an unmarked mass grave. In 1874 these men set out with guide Alfred Packer to cross the mountains of Colorado's west slope and seek work in the San Luis Valley. The group, caught by a blizzard just north of Slumgullion Pass near the mining town of Lake City, was stranded for most of the winter. When the snow melted, Alfred Packer, Hinsdale County's famous cannibal, was the only man left alive. Packer claimed that he killed the others in self-defense and ate them only as an afterthought, but he was convicted of the murders and thrown into prison. The judge is supposed to have said, before sentencing him: "Alfred Packer, you scoundrel, there were only seven Democrats in Hinsdale County and you ate five of them!"

In 1989 a group of forensics experts had the bodies exhumed and examined the remains, trying to verify or disprove Packer's cries of innocence. The results of the inquiry were inconclusive, but the remains were sorted and finally given a decent burial.

Secular Images / 149

William Large met with a common demise in Lake City, Colorado.

Lucas, Kansas, is home to one of America's most fantastic folk art sites—the "Garden of Eden," created by S. P. Dinsmoor. The complex centers around his so-called Cabin Home, a stone cabin that is made to look like a wooden one, with post stones cut and assembled as if they were logs. North-central Kansas is famous for its stone fence posts, used by farmers because very few trees were native to the area. The inside of the house is filled with strange details. No two doors are the same height. Some of the handmade furniture features complex wood inlays. A sculpted self-portrait is situated outside, waving, so that his wife could see him as she worked at the sink. Dinsmoor began the Garden of Eden before 1910 and finished it shortly before his death in the early 1930s. He and his first wife, Frances Journey, were married on horseback, an event that set the tone for a passionate and eccentric life.

The grounds that surround the house are bordered with monumental concrete sculpture that depicts scenes from the Bible and makes reference to Dinsmoor's populist sympathies. At the east edge of the property, a figure named "Labor" is crucified by a banker, a lawyer, a doctor, and a preacher. In

the northeast corner of the complex stands the mausoleum, which contains Dinsmoor's remains in a coffin with a sealed glass window displaying his moldering features. Below him, unseen, Frances is buried. Dinsmoor built the mausoleum some time before his death, and it is decorated with some of the same symbolic concrete statuary that makes up the rest of the site. Dinsmoor delighted in shocking people with his passionate views and his sense of humor about his own death. It is said that he used to keep the coffin in the basement of the cabin home and would occasionally climb into it for the amusement of his visitors.

After the death of his first wife when he was 80, Dinsmoor married a 20-year-old girl named Emilie Brozek, and they later had two children. She is said to have done some of the work on the Garden of Eden, and their April-December marriage was, by all accounts, lively and meaningful.

Although the mausoleum is watched over by a concrete angel, the building is more about Dinsmoor's individual spirit than it is about religion.

*Secular Images* / 151

# Children

Grave markers for children are uniquely poignant monuments. The death of a child is a violation of the natural process. Children are the future, so there is a special sadness, anger, and emptiness that follows the snuffing of such small, brief candles. Familiar images, such as lambs or fallen birds, are used to mourn the loss of children, and even in their most prosaic forms, they evoke universal and collective feelings of loss. When the images are particularized, they tend to call forth a deeper grief. In the case of Hattie Waller of Wichita, Kansas, the monument that depicts her with the family dog is relatively straightforward, but it has a haunting quality that has fascinated people for most of this century. Too often, the story that goes with a given image is long since forgotten. At Maple Grove Cemetery, in Wichita, Kansas, this particular story survives.

Hattie Waller was born on September 21, 1885, the only daughter of Clara and Fred Waller. Her father was a teller at a Wichita bank and her mother came from a prominent local family. The Wallers were cordial and popular in Wichita society, but daughter Hattie was the focus of their lives. As happened so often in those days, Hattie came down with typhoid and died on November 18, 1889, at the age of four.

Clara and Fred hired an immigrant German stonecutter named Stephen Hesse to sculpt a monument for her. He worked from photographs of Hattie and her dog, creating a good likeness that won praise from the *Eagle,* Wichita's newspaper:

> The long skirt which reaches her ankles was very full, and fashioned of an elaborate pattern of solid embroidery. All of these difficult and intricate details have been reproduced in stone with amazing fidelity. The expression of her face and the grace of her pose have been caught by the sculptor with a skill that makes the little image strikingly lifelike. The water spaniel at her feet with his thick, curly coat, must have looked in life much the same as we see him today, in stone.

Unfortunately, the Vermont marble used by Stephen Hesse has begun to wear away into generalities, but the statue still retains its haunting charm, and the ongoing attention of local residents. Long after the family moved to the East Coast, flowers were kept tucked under Hattie's arm. Sometimes they were fresh, more often artificial, but she was never without them. Speculation about the source of the flowers became a matter of public conjecture, but for years remained a mystery. Wichita enjoyed the mystery and took pride in the continuing care that was lavished on the little girl's memorial, long after the family had left the area.

In 1990, the mystery was finally solved. Lorene Kerns, age 78, admitted to being the one who kept flowers on the grave. She had played in Maple Grove Cemetery as a girl and had become fascinated with the statue of Hattie. "I always wondered if the dog was buried with her," Lorene said in a newspaper interview.

Plans have been discussed with the descendants of Stephen Hesse to build a cover or gazebo over the statue to prevent further deterioration, but, as of this writing, nothing has been done. It is assured, however, that flowers will continue to be placed there. Lorene Kerns has convinced her granddaughter, thirteen-year-old Beth Caruso, to take over the task once she is gone.

No tale survives for this dapper seven-year-old boy, who strikes a jaunty pose in Bellefontaine Cemetery, St. Louis, Missouri.

154 / *Soul in the Stone*

This Denver, Colorado, lamb, worn away by the seasons, is an example of the most common motif used to indicate a child's grave. In Christian iconography, the lamb represents innocence as well as obedience to the faith.

Children / 155

In Aspen, Colorado, the hand of God reaches down to pluck the flower of youth.

Ella Perkins is shown as a fallen bird. This crudely repaired stone, carved in Beloit, Kansas, can be found in the Lincoln, Kansas, cemetery, across the road from the traveling salesman's suitcase monument.

Children / 157

Artie and Willie huddle together and stare forever out into the surf in a corner of Calvary Cemetery that overlooks Lake Michigan, just inside the Evanston, Illinois, city limits. Their soft marble features will be gone in another generation, "scrubbed off by the sun," as Dylan Thomas would say.

158 / *Soul in the Stone*

The misspelled inscription adds more pathos to this stone, which now lies flat on the ground in tiny Ontario Cemetery, Ames, Iowa.

Children / 159

The sculpted portrait of this Chicago youngster, who died before the turn of the century, stays crisp, thanks to the protection of his strange little sentry post.

160 / *Soul in the Stone*

Lulu Fellows sits—book always open to the same page—sheltered from Chicago's winds.

Protected from the weather, Inez Clark is portrayed as an impeccably dressed six year old keeping watch over her corner of Chicago's Graceland Cemetery.

162 / *Soul in the Stone*

Children / 163

Dashed hopes are represented by a spilled flower pot in Leadville, Colorado.

164 / *Soul in the Stone*

Beautifully sculpted limestone marks the grave of America Harding, who is shown as a benevolent maid feeding grain to a lamb. America's parents may have been recent immigrants, who paid the ultimate tribute to their newly adopted country by naming their daughter after it. This monument is at Bellefontaine Cemetery in St. Louis, Missouri.

A memorial to the Morrison brothers recalls their short lives as invalids, one confined to a wheelchair and the other to his crib. The chair's wheels are broken by design, but the meaning is not altogether clear. They may symbolize broken lives and the impermanence of all earthly things. On the other hand, they could represent the child's freedom from his earthly prison of pain and illness. This striking but quickly deteriorating monument is at Calvary Cemetery in St. Louis. The impact of this image is unusually morose for an American monument. The children's eyes seem to be full of uncomprehending terror, bringing to mind the bitter, nihilistic markers that haunt some of Europe's metropolitan cemeteries.

This sentimental Hays, Kansas, monument provides a striking contrast to the Morrison memorial.

*Children* / 167

A grave marker by Horace McAfee in the San Juan Cemetery near Chilili, New Mexico, provides a radically different approach to a child's monument. The cross looks to be a manufactured item, but it is hand-tooled to say "God's Baby." The lower plaque, which says, "made by Horace McAfee," is double padlocked to a piece of cable. At the foot of the grave, beyond the Jesus Christ reliquary, is a strange diagonal piece of metal post, which is chained to the rest of the complex. It supports a sign which says "Visitors Welcome, Photos Allow."

Three-year-old Brucie Dunbar's hat, cloak, and boots are rendered as he might have left them before taking to his sickbed. His nickname is carved along the side of his tombstone. This nineteenth-century limestone monument is in remarkably good condition. The durability and grain of limestone varies widely from one quarry to the next.

*Children* / 169

Irmgard Christine Winter, buried at Wyuka Cemetery, Lincoln, Nebraska, is remembered by her parents as "our morning glory." The haunting and still-pristine porcelain photograph is several times the size of today's standard snapshots.

The image and the inscription mix metaphors at the grave of this infant in Creede, Colorado.

Peter Burkee's spellbinding portrait floats on a sea of autumn leaves in Aspen, Colorado.

*Children* / 173

This stone in Creede, Colorado, relinquishes a beloved child with touching consent:

> God needed one more angel child
> Amidst his shining band,
> And so he bent with loving smile
> And clasped our darling's hand.

This concrete stone west of Monte Vista, Colorado, incorporates a ceramic doll's head and the familiar "Now I lay me down to sleep" verse, scribed into the wet cement with a knife or nail.

Children / 175

This strange child, kneeling in prayer, is the work of Hance White, who operated the Pittsburg, Kansas, Marble Works from 1892 until his death in 1926. White was a successful businessman, accomplished musician, and folk artist. He decorated his house with sculpted portraits of Christopher Columbus, George Washington, Mark Twain, and Belle Starr, as well as fans, torches, and other decorative objects. He also marketed tombstones all across the Great Plains, eventually opening a branch of his business in Miami, Oklahoma.

In Milwaukee, Wisconsin, and Nebraska City, Nebraska, images that are worn and brief nevertheless remain eloquent.

Children / 177

A mother and daughter cling to each other at the cemetery in Boonville, Missouri. This lichen-covered marble sculpture remembers Kate, only daughter of Joshua and Catherine Tracy, who passed away in 1854 at age seventeen. An archaic and barely readable inscription on the back side of the monument reads:

>Here love her sacred vigil keep,
>Our dust that in love silent sleeps.
>Our faith looks up and eager lyes
>To meet her spirit in the skies.

In Chicago, Frances Pearce and her child lie together, sheltered from the wind and rain. This marble monument is one of many protected from the elements in Graceland Cemetery.

Mandy Moore's family erected this black granite memorial in the shape of a piano to celebrate Mandy's contribution of music and joy to the world she briefly occupied. Her tombstone is surrounded by drab, repetitive blocks of stone; this Oklahoma City family was obviously not willing to settle for the ordinary.

180 / *Soul in the Stone*

Millie, Freddie, Marie, Walter, Hugo, Edna, Russell, and poor Cecile attest to the high attrition rate of frontier families in the newly developing heartland of America.

*Children / 181*

182 / *Soul in the Stone*

Carrie Francis, daughter of F. A. and R. S. Kiene, is shown as a pious five-year-old who cradles a cross and looks thoughtfully into unfocused space. This sculpted portrait, which is often decorated with a garland of silk flowers, sits in Topeka's Mt. Hope Cemetery, among rows of prosaic stones. The inscription, put on in 1885, reads:

> I cannot return to you
> But you can come to me.

Two gravestones, erected almost a hundred years apart, use the lamb of innocence, along with a photograph of the child, to mourn the losses of families in Iowa and Missouri.

Children / 185

186 / *Soul in the Stone*

Eva Whipple, who slumbers at Bellefontaine Cemetery in St. Louis, and two unidentified cherubs at Wichita's White Chapel Memorial Gardens share an odd image. The seashell brings to mind the birth of Venus.

188 / *Soul in the Stone*

In Wichita, Kansas, a child clutches flowers and gently urges us to read. The message is universal, but it was written by Samuel L. Clemens after the loss of a beloved wife and two daughters.

Children / 189

# Umbrella Organizations

In death, as in life, some people are joiners. Fraternal organizations and military service carry with them a kind of collective identity and sense of community that are similar to and indeed often mixed with religious faith. Sacrifice seems more noble and meaningful when it is shared. Danger and even mortality are more easily faced when like-minded comrades stand alongside. Fire fighters and police officers are often buried in groups that resemble family plots. The shared pleasures, disciplines, and philosophies that come together under the auspices of the Elks, Odd Fellows, and Masons begin, at times, to simulate the family experience.

The International Order of Woodmen of the World and its sister organization, Women of Woodcraft, are essentially a fraternal insurance company. Membership included a benefit of fifty to a hundred dollars toward the purchase of a tombstone, as part of the policy. The distinctive design and logo provided the company with some durable advertising, and they provided the cemeteries of America's Heartland with some of their most interesting and beautifully realized tombstones. The Woodmen's motto—"When silent he speaks"—often appears on the stones, along with the familiar crossed axe and mallet. Variations on the theme of wood dominate in monuments erected by this group. Mortality may be represented by a sawed, broken, or decaying tree trunk, but more often it takes the form of logs harvested and stacked, like God's chosen people, waiting eagerly for the final blaze of judgment. This particular stone stands at Mount Mora Cemetery, in St. Joseph, Missouri.

In Aspen, Colorado, a Women of Woodcraft monument
adds a lily and a Bible to the usual ensemble.

192 / *Soul in the Stone*

The shrouded canon, retired from service, is a common motif used to honor those who served in the military. This example is in Kansas City's Forest Hill Cemetery.

*Umbrella Organizations* / *193*

An elaborate version of the military theme marks the resting place of General Richard Barnes Mason at Bellefontaine Cemetery in St. Louis, Missouri. The passing of the commander of the U.S. Army's First Regiment of Dragoons is represented by a cannon that has been disassembled and covered. The inscription reads:

> His tender care and noble virtues live in our hearts.
> His services to his country are identified with its history.

Born at Harper's Ferry, Virginia, Jeff Thompson moved to St. Joseph, Missouri, in the 1840s to become a surveyor for the New Hannibal and St. Joseph Railroad. He was elected mayor of the city in 1859 and presided over the inauguration of the Pony Express in 1860 but soon was caught up in the cause of the Confederacy. In 1861 he led a mob that tore the American flag from the post office. Martial law was imposed in St. Joseph and stayed in effect for the rest of the war. Jeff Thompson escaped to Louisiana and fought with the rebel army for the entire war, earning the rank of Brigadier General and the nickname "Missouri Swamp Fox," which celebrated his wily and elusive guerrilla tactics. After the war he stayed in Louisiana, to become surveyor general of the state. Eventually he returned to Missouri and died in St. Joseph in 1876, just a few yards from the spot where he had torn down the flag fifteen years earlier.

These humble soldiers, at rest in Denver and Chicago, have discarded their hats and gear for a well-deserved eternity of leave.

196 / *Soul in the Stone*

An ordinary-looking cross in St. Joseph's Mount Mora Cemetery broods over a sordid story connected with the death of Sir William Wisemann, rear admiral and knighted servant of the Crown. Sir William and a group of compatriots traveled to Missouri in the spring of 1874, to do some hunting along the Missouri River. A good time was had by all until Sir William fell ill and died of pneumonia. He was interred in St. Joseph, and a letter was sent to his widow asking her about arrangements to transfer his body to England. She sent a curt note back to the authorities in Missouri informing them that as he had elected to take his mistress and not his wife on the trip, as far as she was concerned, he could stay there and rot. More than a hundred years later, the remains of Sir William Wisemann are still at Mount Mora Cemetery.

*Umbrella Organizations* / *197*

William Tecumseh Sherman, the Civil War general, is remembered chiefly for his famous "march to the sea," which broke the back of the Confederacy and marked the beginning of the end of the war. Sherman is buried at Calvary Cemetery in St. Louis beneath a flag-draped monument that also features the depiction of an arrow, reminding us of his relatively constructive service in "Indian affairs" on the frontier, as well as a military medal, inscribed "40 rounds," and an acorn, a symbol of strength.

Sherman's wife, Ellen, and two sons are also buried nearby, including nine-year-old "Sergeant Willie," who died of typhoid while visiting a Union Army camp at Vicksburg, Mississippi. Willie was a favorite with the soldiers, riding in drills and taking an intense and precocious interest in all the affairs of the camp. When his illness reached the critical phase he talked earnestly with a Catholic priest, telling him that he did not mind dying, if it was God's will, but it pained him to leave his mother and father. The priest was moved and impressed by Willie's bravery. Willie was given a military funeral by the Thirteenth United States Regulars but on his Calvary tombstone he is remembered by a sad non-military phrase: "In his spirit there was no guile."

198 / *Soul in the Stone*

The city of Denver erected this monument to area firemen who died in the performance of their duty. A hose, ladder, and fireman's hat are sculpted in relief on the granite obelisk, and individual graves are marked by identical stones, much like those in military cemeteries. The lack of ostentation or individual expression reinforces the concept of the "good soldier," who toils for the collective benefit of all and wants to be thought of as one of the team.

*Umbrella Organizations* / 199

The tools of his trade are carved on the tombstone of an Aspen, Colorado, fireman, who died in the late nineteenth century.

An early horse-drawn pumper tram is represented on a group monument in Chicago's Rose Hill Cemetery.

200 / *Soul in the Stone*

Thomas Gallagher of Chicago and other members of his family lie near this stone tree monument, which by the star and baton seems to indicate that Tom was a policeman. His widow endured his untimely death shortly after the loss of a young child, and later the loss of a son in the final days of World War I. An inscription on the back of this stone seems to accept these sacrifices without question: "Thy Will Be Done."

*Umbrella Organizations* / 201

Wyuka Cemetery in Nebraska City holds this unusual monument, which uses the fungus-covered tree stump to display the three rings that are the hallmark of the Independent Order of Odd Fellows, and includes the boulder, on which we see a Mason's emblem and an open Bible.

In Denver's Fairmount Cemetery, a man of industry and faith is remembered by depicting his workshop, tools, and ongoing projects. The images on the wall, which presumably had important symbolic meaning, have been rendered unreadable by the passage of time, but the inscriptions still provide some information about his nature:

> He died as he lived, believing in God
> and the great judgement day.
>
> Here rests a Woodman of the World.

*Umbrella Organizations* / 203

Cassius M. White, Supreme Commander of the American Woodmen, passes the torch to a new generation of followers.

204 / *Soul in the Stone*

The Brotherhood of the Paternal Order of Elks occasionally provides a life-sized bronze Elk to overlook an area of a cemetery set aside for members and their families, but their imagery is used on individual stones as well. The familiar "eleventh hour" motif is the predominant symbol of this organization. It honors the dead and absent Elks by calling for a moment of quiet reflection on the sounding of that hour: "When this hour falls upon the dial of night, the great heart of Elkdom swells and throbs."

206 / *Soul in the Stone*

# Ethnic Influences

Leaving aside Native Americans, the United States is a country consisting of relatively recent immigrants. Customs and traditions of the Old World have been transported and continued, as a way of providing homesick pioneers with a sense of structure and belonging in the trackless, unfamiliar landscape of North America. Some funerary art, like the Hispanic style, developed and changed in the New World, while other traditions, such as the German iron crosses, were brought intact, used for a generation or two, and then abandoned in favor of generic American monuments.

The stone erected for Henry Rawie, a German immigrant who died in Femme Osage, Missouri, is a classic Protestant tablet, decorated at the top by an angel who points up to heaven and inscribed with an epitaph in archaic German. This tombstone closely resembles those that were imported from the British Isles and could be considered among the least exotic of immigrant monuments.

These monuments, also made by German immigrants who came to America after settling in Russia under the brief sponsorship of Catherine the Great, resemble crosses made in Bavaria and other Germanic areas that were loyal to the Catholic Church during and after the Reformation. Sunset at Liebenthal, Kansas, provides a dramatic backdrop for the bold and elegant wrought iron crosses.

*Ethnic Influences / 209*

Compare the Liebenthal crosses with
these two, photographed in Bavaria.

210 / *Soul in the Stone*

Ethnic Influences / 211

These wrought iron and sheet metal monuments, photographed at St. Peter's churchyard, in Salzburg, Austria, illustrate the intricacy and variety that mark the work in this medium. Sheet metal surfaces are often illustrated with bright colors against the black.

Not as varied as the previous examples, but nonetheless elegant, these crosses were probably done by either John Knoll or Alois Hauser, rivals who tried to surpass one another in decades of work that usually ended up in St. Fidelis Cemetery, just north of Victoria, Kansas. Both of these blacksmiths turned sculptors died in the 1930s, but the tradition was carried on by others. Surprisingly, one of the attractive aspects of these crosses was cost. An average iron cross cost about twenty dollars, very inexpensive compared to a carved tombstone.

Ethnic Influences / 213

Even with the addition of decorative filigree, the use of utilitarian pipe to form the cross gives this monument a humorous, blue-collar look and makes the visitor wonder if Herman Heinrich Tholen might have been a plumber.

214 / *Soul in the Stone*

The addition of curvilinear icing did not save this pair of Liebenthal crosses from looking like clothesline poles. The graceful spire of the Liebenthal church in the background only serves to make the monuments look more utilitarian and brings to mind the Mamluk tombstones in Cairo's "City of the Dead," which regularly support lines full of multicolored laundry.

Ethnic Influences / 215

Photographed against the background of violent Kansas weather, a later version of the Victoria, Kansas, cross, done in the 1950s, pays homage to Bavarian wrought iron and at the same time looks a little like a fancy storm door. The St. Fidelis Cemetery holds dozens of crosses, each one a little different from the last. Also nearby are two family "grufts," small brick buildings which contain an altar for meditation and an underground crypt, which is reached by lifting a locked iron door that sits at ground level.

216 / *Soul in the Stone*

Also numerous in Liebenthal, Victoria, and Hays are cast metal crosses, much like those seen all over France and in Catholic Germany. These crosses are made of a variety of alloys. Since they were cast in large numbers rather than sculpted, they were very inexpensive.

*Ethnic Influences / 217*

In Oklahoma City, a stray iron monument lurks among the rows of granite. This complex and lyrical tribute to Emma Buchse was presumably made in 1896, the year she died.

In the predominantly Czech cemetery at Wilson, Kansas, a tombstone cast from "blue bronze" alloy depicts a hand dropping a tribute of flowers.

*Ethnic Influences* / 219

This Jewish monument depicts the traditional Star of David on an elaborate wrought iron structure.

A small wildflower managed to take root in a crack between slabs of granite on this modern Jewish marker in Denver.

Hispanic tombstones have developed and evolved in the New World over a much longer period of time than those of other immigrant cultures. They predate most other European arrivals in the Heartland by two or three hundred years. This tombstone, in Santa Fe's Rosarie Cemetery, is fairly recent, but some of the detailing betrays a connection with Mexican funerary traditions. The winged hourglass is a universal European and American motif, but at the very top of the stone, a heart nestles between two crossed bones that are tied with ribbon or string. This image brings to mind not only the Spanish and Italian preoccupation with the reliquary but also the "Day of the Dead" celebrations in Mexico, when the bones of loved ones are at times disinterred, washed, and tied with new ribbon. In this ceremony, food is left out overnight for the dead to eat, and the presence of the living in the cemetery is true interaction on a level not understood in northern European cultures.

The image of a storm-tossed figure delivered from the tempest illustrates the reliance of much of New Mexico's culture on the Catholic Church. This theme is common in Catholic cemeteries and is usually accompanied by the phrase: "To thy cross simply cling."

Ethnic Influences / 223

224 / *Soul in the Stone*

The Topeka, Kansas, grave of Teresa Rocha is marked with a marble child, a lamb, and a sad inscription: "The Lord took our beloved angel from this world." Looking up at the Rocha monument is a cast concrete infant, with a scrawled notation: "Infant Gonzales."

In Topeka, Kansas, an angel hangs a wreath of flowers to commemorate the death of one of the Hispanic community there.

Ethnic Influences / 225

In a rural graveyard near Galisteo, New Mexico, red sandstone monuments brave the intense desert sun. This stone depicts the communion chalice.

226 / *Soul in the Stone*

Another Galisteo stone, which urges us to pray for the deceased, brandishes the cross and a cryptic flourish at the bottom.

*Ethnic Influences* / 227

A stone at Galisteo Cemetery may illustrate an interesting bit of Spanish history. Many Spanish Jews escaped the Inquisition in Spain by joining the conquistadores and pretending conversion to Roman Catholicism. These emergency immigrants lived in Mexico and Central America but some gradually moved into New Mexico. Generations of these people lived as "hidden Jews," practicing their rituals in secret and developing a compulsively cryptic way of life that hid their true faith even from their children until they were mature. Occasionally the hidden Jews would add a seemingly decorative mark on their tombstones, such as a six-petaled rose to represent the Star of David, in a kind of shadowy declaration of their true faith. Do these six-pointed star shapes indicate some connection with a Jewish family?

228 / *Soul in the Stone*

The cross at Magdalena Gutierrez's grave, near Chilili, New Mexico, is poured concrete with marbles added for festive color. There appears to have been a plaque or photo in the center of the cross that has been lost.

Ethnic Influences / 229

The small San Francisco Campo Santo, on the road between Santa Fe and Taos, holds a concrete cross that has rocks and a wood panel pressed into it, as well as decorative linear inscribing and a plastic statue of a praying female figure.

This complicated handmade ensemble in Alamosa, Colorado, includes painted concrete, plastic flowers, crucifixes, and images of the Virgin and various saints. The sense of abandon inherent in many Hispanic monuments helps sustain the imagery's joyous, overflowing quality even in the midst of harsh poverty.

Ethnic Influences / 231

At El Prado's St. Delores Cemetery near Taos this beautiful folk art grave marker makes use of what appear to be fish heads to form the tips of the cross. On the arms and shaft of the cross are whole fish that turn on the nails which attach them. The once bright colors had faded by the time this photograph was taken but there was still an exuberant quality about this somewhat mysterious monument, which is garnished with plastic flowers and a grass wreath wrapped in ribbon. The fish is an ancient Christian symbol, dating from the time of clandestine worship in Rome's catacombs. The fish on this one-of-a-kind monument may have been Christian emblems or simply artistic flights of fancy. The grave site is still planted in iris, but the ensemble of gaiety and affirmation is now gone. Only a couple of months after this photograph was taken the cross disappeared, thrown away by overzealous caretakers or stolen by one of the increasing numbers of thieves who raid cemeteries looking for folk art and curiosities.

In the St. Delores Cemetery, Michael Martinez is remembered by a decoupaged and varnished cross decorated with images of exotic women and a "low rider" Chevy, as well as a photograph of the deceased and the obligatory Christ carrying his cross. Accessories covering this monument include a rosary, a brightly colored handkerchief, and a mysterious beaded artifact that hangs from a leather thong. A woman named "Lil" has left a dated signature amid the cluster of female faces on the right arm of the cross.

Just across the fence, in the adjoining cemetery that sits within the Taos city limits, another variation on the Campo Santo cross displays an unusual detail: small, brightly painted wooden artifacts that slide along a wire.

Ethnic Influences / 233

A small cemetery on a hill overlooks San Luis, Colorado's, oldest town, which is known for its series of shrines depicting the twelve stations of the cross. This unusually complex homemade tombstone features a communion cup that partially envelops the wafer of the host, the symbolic body of Christ. The burning candles of faith may represent the Trinity, and the Holy Spirit descends from the top in the form of a bird. A praying woman at the bottom may represent Juanita Romero, whose name is inscribed near the top—or she may be a representation of any number of Catholic figures, such as Our Lady of Guadalupe or St. Teresa of the Little Flower.

A stone in the San Luis cemetery displays the cross. The relatively high relief of this carving, plus the dry climate, has kept this image crisp for generations.

*Ethnic Influences / 235*

The cross appears everywhere in Hispanic cemeteries. This unusual example, located near San Luis, Colorado, is also surrounded by an iron fence that takes the form of attenuated Latin crosses.

This marker uses pieces of flat, decorative tin, as well as marbles.

In a nameless cemetery at the west edge of Monte Vista, Colorado, this cast concrete monument glitters in the thin high-desert air. Dozens of multicolored marbles bring the otherwise bleak site to life.

*Soul in the Stone*

In Denver's Fairmount Cemetery, an Eastern motif gives hope that Oriental immigrants will not give up entirely on the beliefs of the homeland. Within the mouths of the lions are freely moving balls that are larger than the mouth openings—all carved from the same stone. Chinese artisans have traditionally carved decorative ivory balls of diminishing size within others.

Ethnic Influences / 239

# Ashes to Ashes

We have taken the classical Heartland cemetery for granted, and while we as a society were not looking, monuments that seemed permanent have begun to disintegrate and be destroyed. The artistic inclination and skill that created these monuments seem in short supply now. The Heartland cemetery, like its counterparts across much of the nation, is slowing evolving into a "memorial park," a flat, mute wasteland, invented for the convenience of the new owner-operators. Ease of maintenance is given preference over the individual expression of love and grief. Naked ladies and cowboy boot vases full of flowers are forbidden.

There are heartening signs that segments of society are beginning to rebel and demand the right to individual expression and mourning. Interesting, sometimes entertaining illustrations have begun to appear on what had become the standard pastel granite tombstone. The means toward truly broad expression are greatly diminished, however, compared with the poetic facility of the nineteenth-century monument maker. We do not have multitudes of skilled stone cutters and sculptors, ready to breathe life into individual and collective philosophies or images, but if we truly wanted them they would return. Our society needs to redefine how it feels and thinks about mortality and insist on having options for the expression of those feelings and thoughts, be they the erecting of edifices or the scattering of ashes. The signs of returning individualism are encouraging, but this nascent impulse needs to be nurtured and expanded if the Heartland cemetery is once more to be a mirror for our rich and varied culture.

The once familiar marble and limestone monuments, fashioned several generations ago, remain one of our best links to the aspirations and values of a society that we still emulate and hold onto proudly in America's Heartland. We are a diverse and independent people, passionate believers and fierce skeptics. These qualities are under attack by consumerism and slickly packaged pop "spiritualism" on TV or in print. That same predatory force urges us, at the end of our lives, to take our places under the rows of identical name plates, leaving neither celebration nor protest to mark our passing. Middle America needs to reassert its multilayered identity if it really wants to be the heart of our nation. One manifestation of our true commitment to those ideals would be to reacquaint ourselves with the tokens and sentiments left behind by those who made us who we are. The Heartland cemetery should be loved and enjoyed, documented and, wherever possible, preserved. If we do not stay in touch with all wellsprings of the Heartland soul, our lives are in danger of becoming as fuzzy as the image on a decomposing tombstone.

242 / *Soul in the Stone*

*Ashes to Ashes / 243*

244 / *Soul in the Stone*

# Bibliography

## BOOKS

Aries, Phillippe. *The Hour of Our Death.* New York: Alfred A. Knopf, 1981.

Benrimo, Dorothy. *Camposantos: A Photographic Essay.* Fort Worth, Tex.: Amon Carter Museum of Western Art, 1966.

Boase, T[homas] S[herrer] R[oss]. *Death in the Middle Ages: Mortality, Judgment, and Remembrance.* New York: McGraw-Hill, 1972.

Duval, Francis, and Rigby, Ivan. *Early American Gravestone Art in Photographs: 201 Outstanding Examples.* New York: Dover Publications, 1978.

Etlin, Richard A. *The Architecture of Death: The Transformation of the Cemetery in Eighteenth-Century Paris.* Cambridge, Mass.: MIT Press, 1983.

Jackson, Kenneth, and Vergara, Camilo Jose. *Silent Cities.* New York: Princeton Architectural Press, 1990.

Marion, John Francis. *Famous and Curious Cemeteries.* New York: Crown Publishers, 1977.

Pike, Martha, and Armstrong, Janice Gray. *A Time to Mourn: Expressions of Grief in Nineteenth Century America.* Stony Brook, N.Y.: The Museums at Stony Brook, 1980.

Sandy, Wilda. *Here Lies Kansas City.* Kansas City, Mo.: Bennett Schneider, Inc., 1984.

Stannard, David. *Death in America.* Philadelphia: University of Pennsylvania Press, 1975.

## ARTICLES

Ambler, Cathy. "A Place Not Entirely of Sadness and Gloom: Oak Hill Cemetery and the Rural Cemetery Movement." *Kansas History Magazine* (Winter 1992–1993).

"Car Engine Tombstone." *Des Moines Sunday Register*, October 25, 1970.

"Children of Israel Cemetery." *Des Moines Register*, April 14, 1993.

Cannon, Aubrey. "Going in Style." *The Sciences Magazine* (November–December 1991).

Fisher, James J. "Gripping Legend." *Kansas City Star*, August 9, 1991.

Hintz, Forrest. "Bohemian Legacy." *Wichita Eagle-Beacon*, August 12, 1981.

Harrison-Brose, Phyllis. "Forever After—Folk Art in Colorado Graveyards." *Muse Magazine* (July 1984).

"Iron Crosses in Ellis Cemetery." *Ellis* [Kansas] *Review*, July 30, 1981.

Roueche, Berton. "Marble Stories." *New Yorker*, October 27, 1986.

Tanner, Sandy. "Hattie Waller's Grave." *Wichita Eagle,* October 25, 1990.

"Tools on Tombstones: Some Indiana Examples." *Pioneer America Magazine* (June 1978).

Wallace, Robert. "Romantic Père-Lachaise." *Smithsonian Magazine* (November 1978).

In addition to the books, periodicals, and newspapers mentioned, other information was obtained in interviews with cemetery caretakers and from pamphlets that are often available at cemetery entrances or from administrative archives.

FOR FURTHER READING

Brown, Frederick. *Père-Lachaise: Elysium as Real Estate*. New York: Viking Press, 1979.

Bunnen, Lucinda, and Warren Smith, Virginia. *Scoring in Heaven: Gravestones and Cemetery Art of the American Sunbelt States*. Aperture Foundation, 1991.

Jones, Barbara M. *Design for Death*. Indianapolis, Ind.: Bobbs-Merrill Company, 1967.

Linden-Ward, Blanche. *Silent City on a Hill: Landscape of Memory in Boston's Mount Auburn Cemetery*. Columbus: Ohio State University Press, 1989.

Ludwig, Allan, I. *Graven Images: New England Stone Carving and Its Symbols*. Middletown, Conn.: Wesleyan University Press, 1966.

Meyer, Richard E., ed. *Cemeteries and Gravemarkers: Voices of American Culture*. Logan: Utah State University Press, 1992.

Morley, John. *Death, Heaven and the Victorians*. Pittsburgh, Pa.: University of Pittsburgh Press, 1971.

Schwartzman, Arnold. *Graven Images: Graphic Symbols of the Jewish Gravestone*. New York: Harry N. Abrams, 1993.

DISCARD